The Swanky Animal Coloring Book

Gabby Long

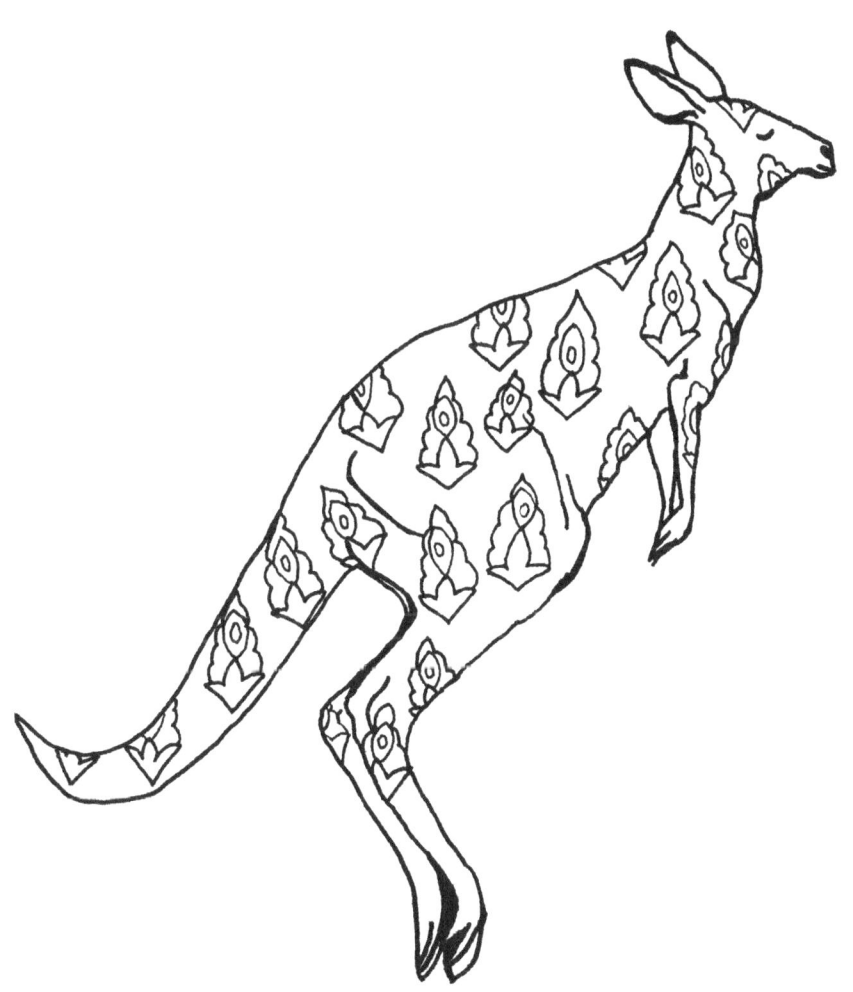

© 2016 Gabrielle J. Long
All rights reserved. No image may be reproduced without written consent from the author.

ISBN-13: 978-1537079578
ISBN-10: 1537079573

Illustrated by Gabby Long
Instagram: @gabby.ink

I hope you enjoy this coloring book! A lot of the animals were drawn from requests, so thank you to everyone who helped inspire my drawings. Special thanks to my Dad for helping me put this book together. I couldn't have done it without him.

Happy coloring!
-Gabby

Please Note:
Putting a piece of paper between pages when using coloring materials that bleed through may prevent ruining the next page. Two blank pages have been supplied at the back of the coloring book for this purpose, if needed.

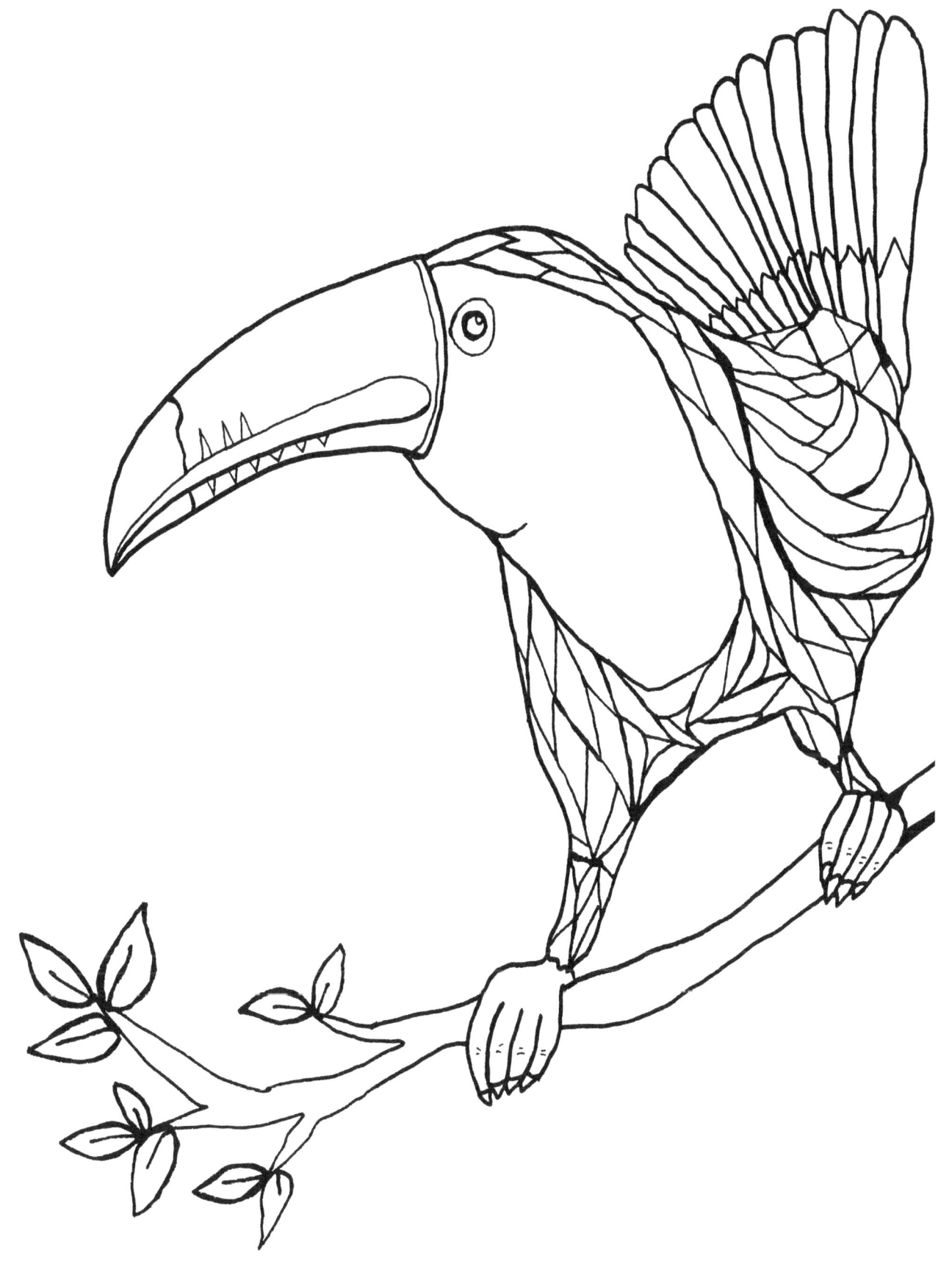

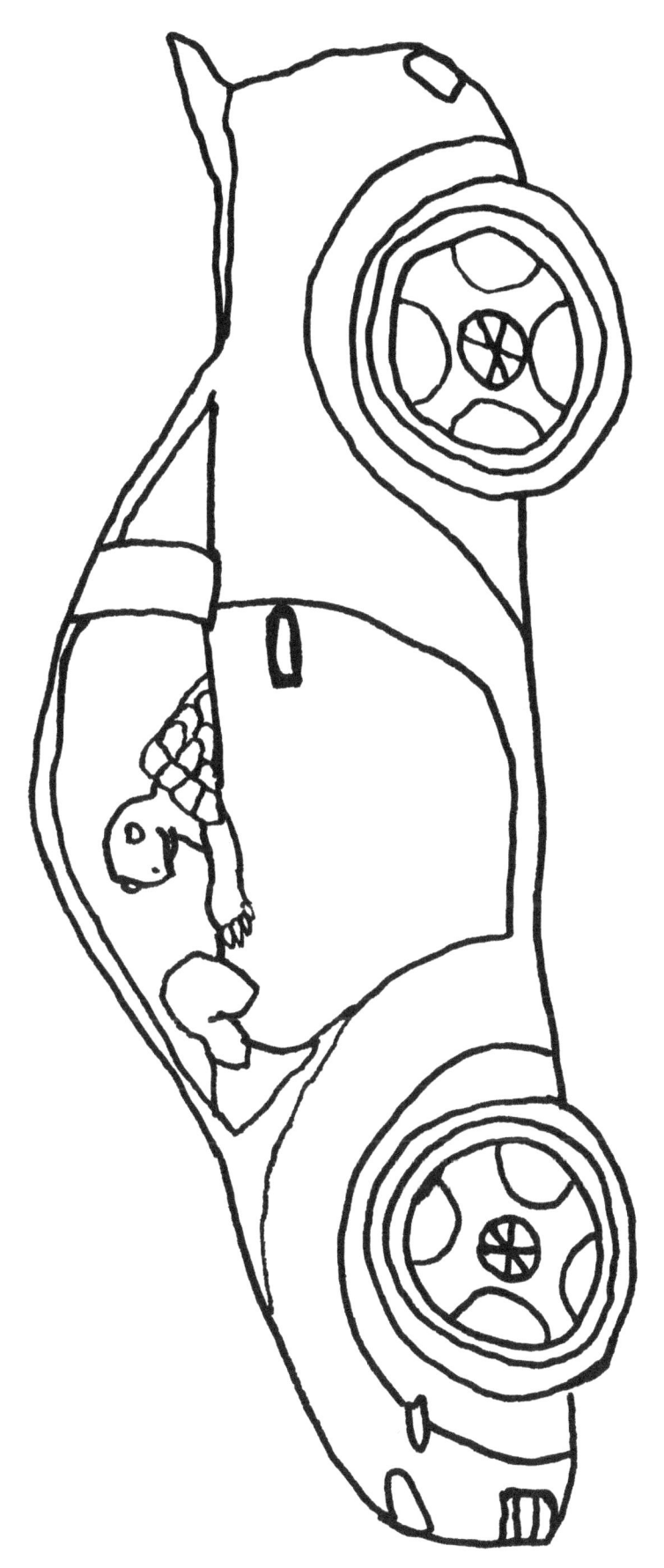

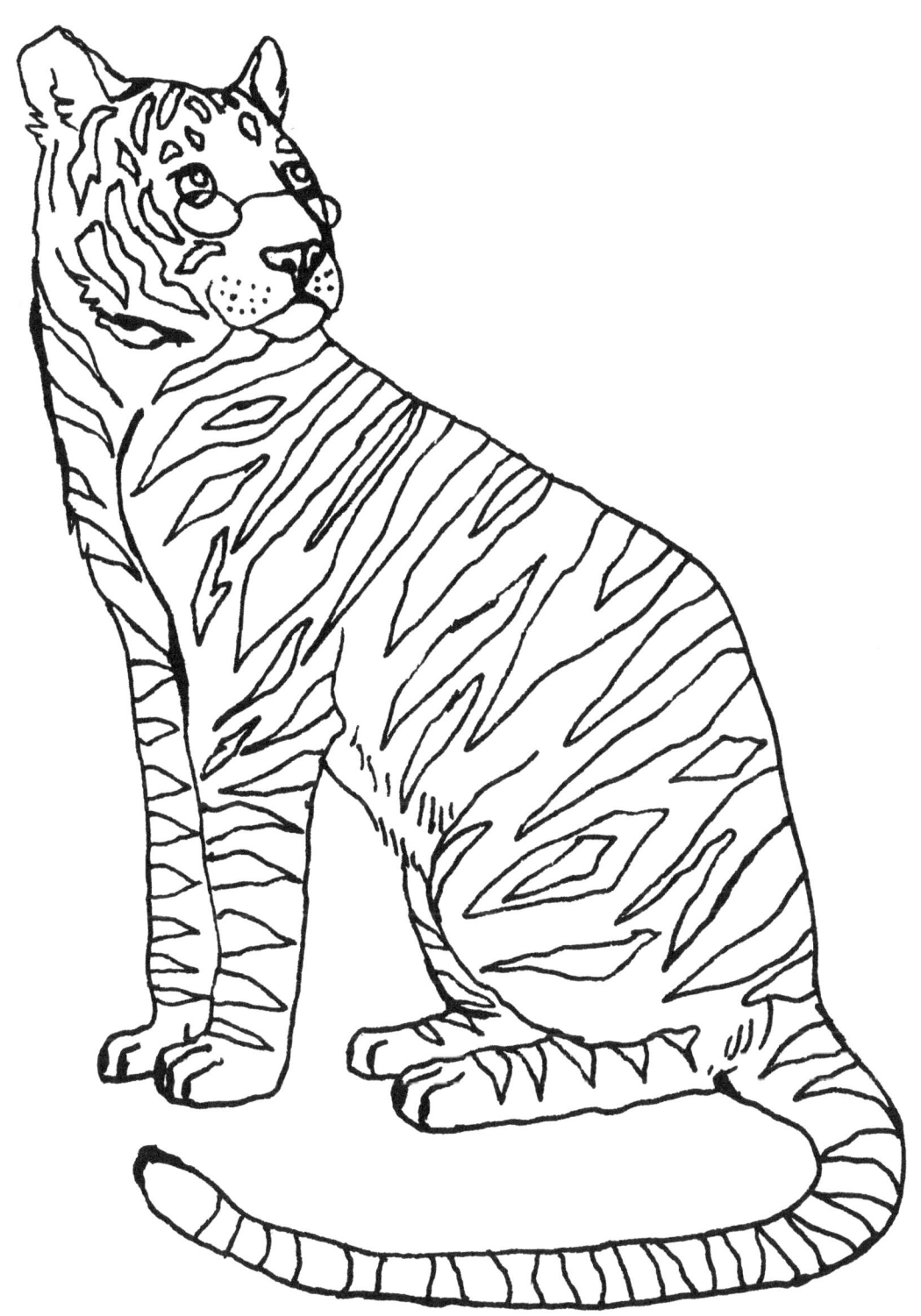

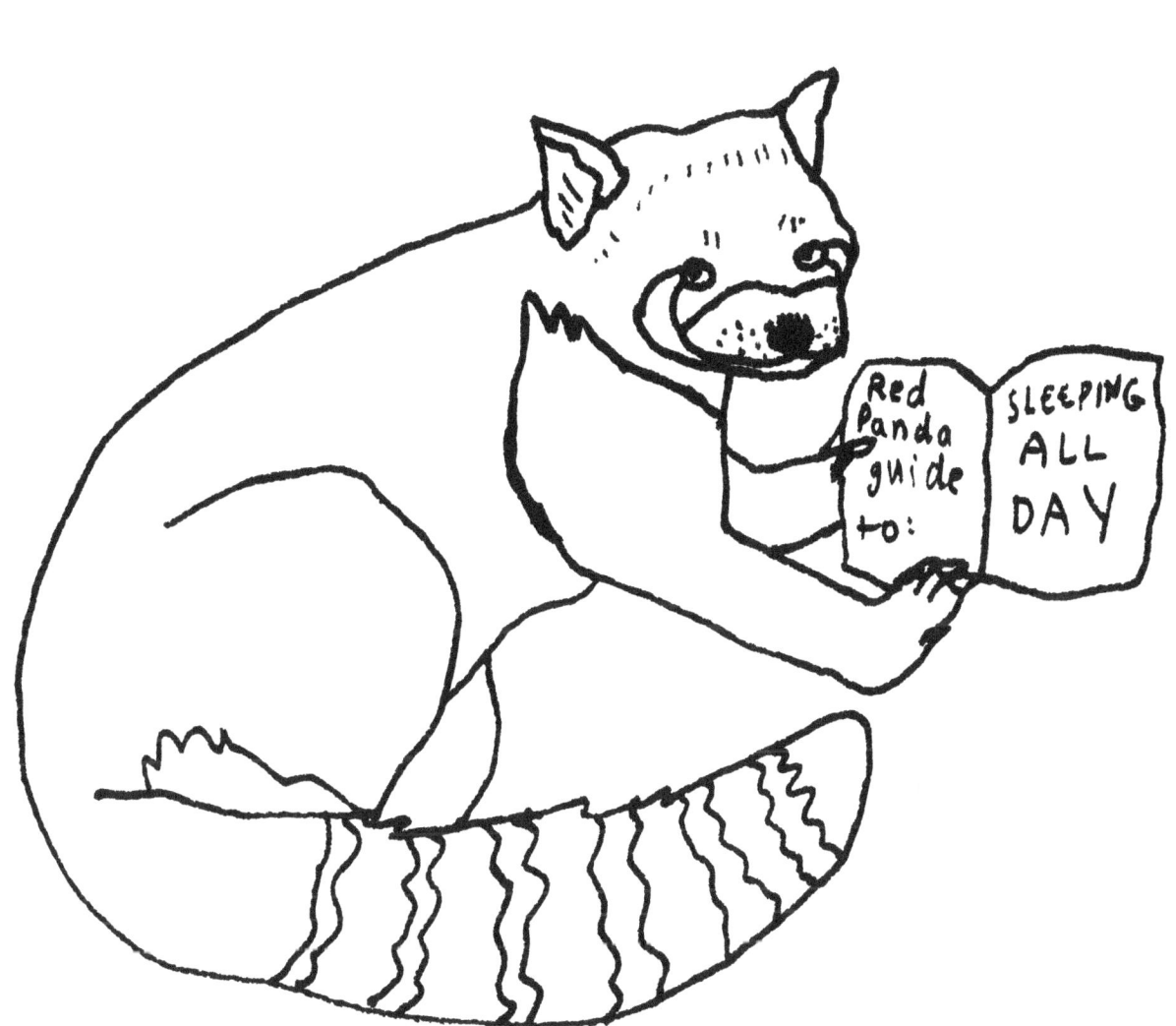

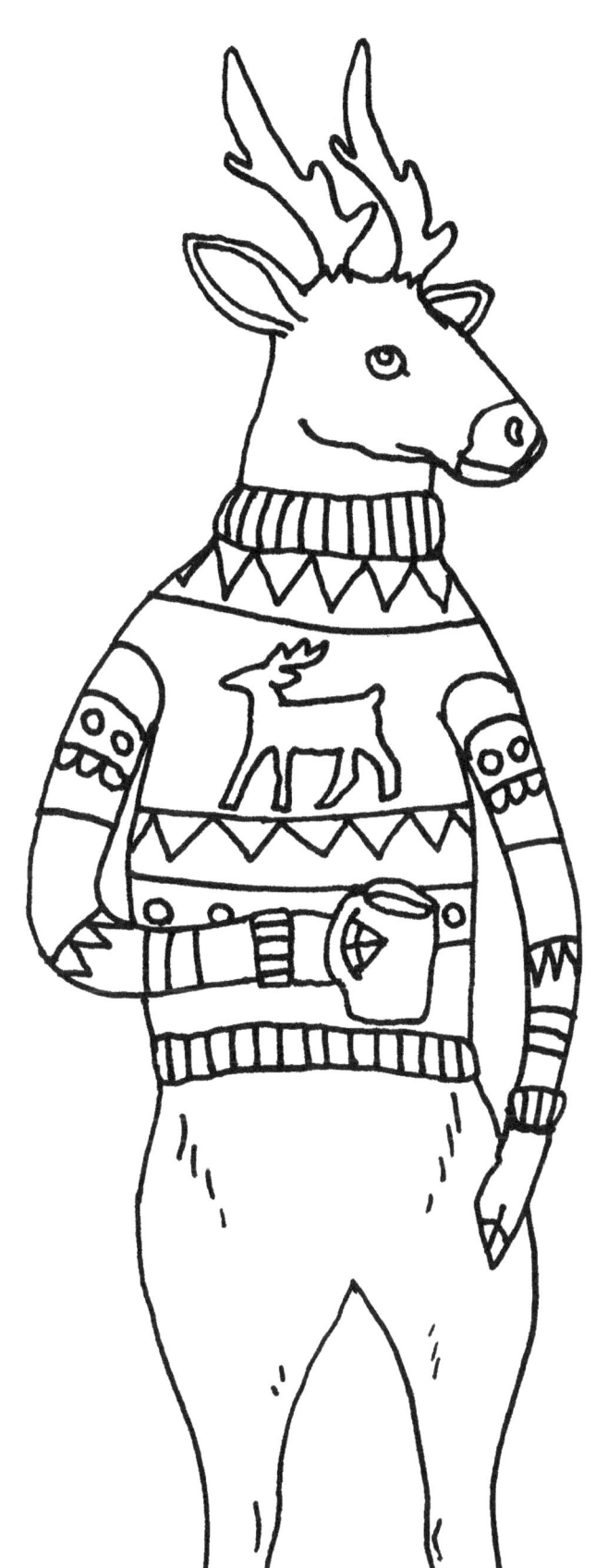

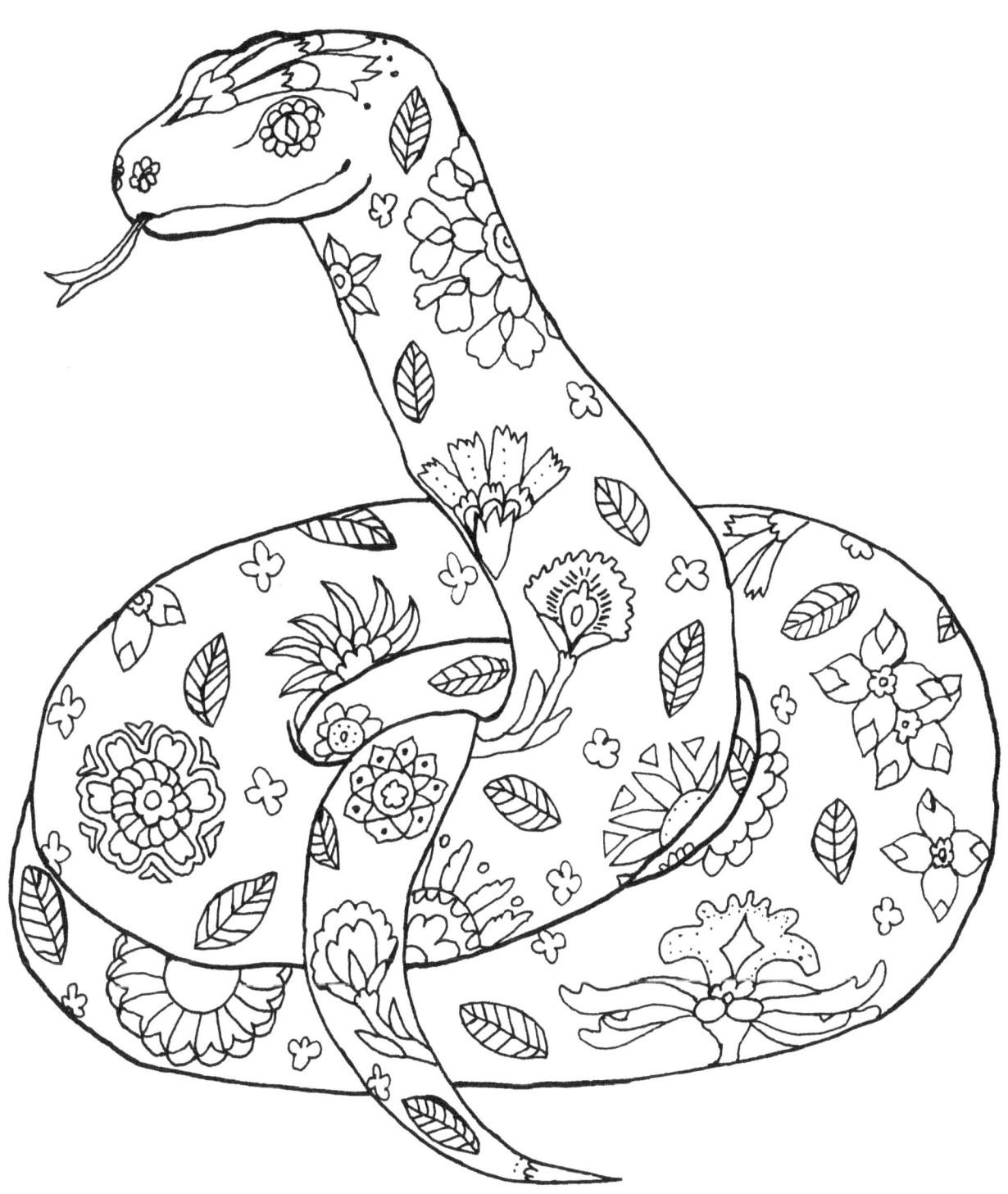

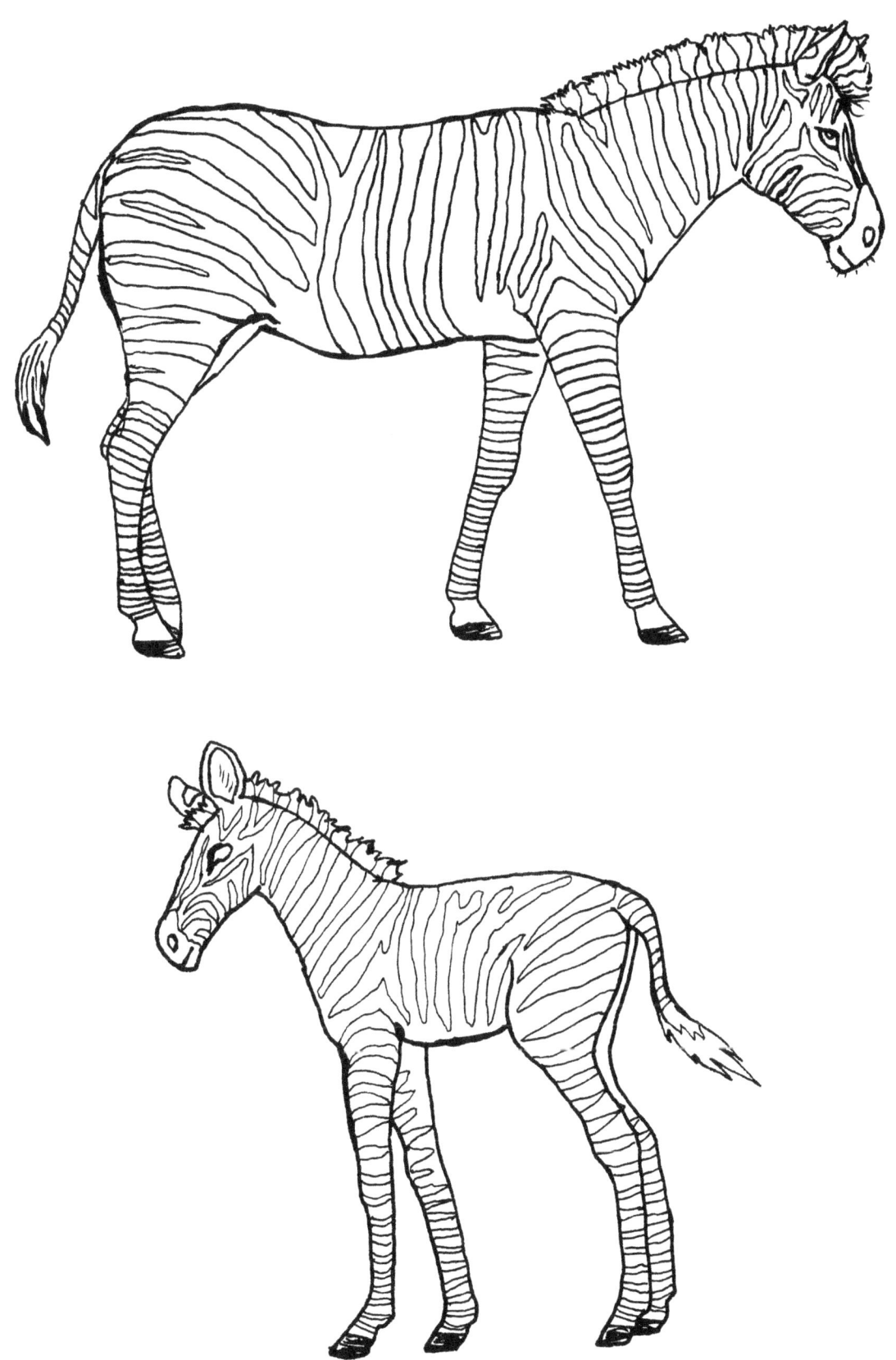

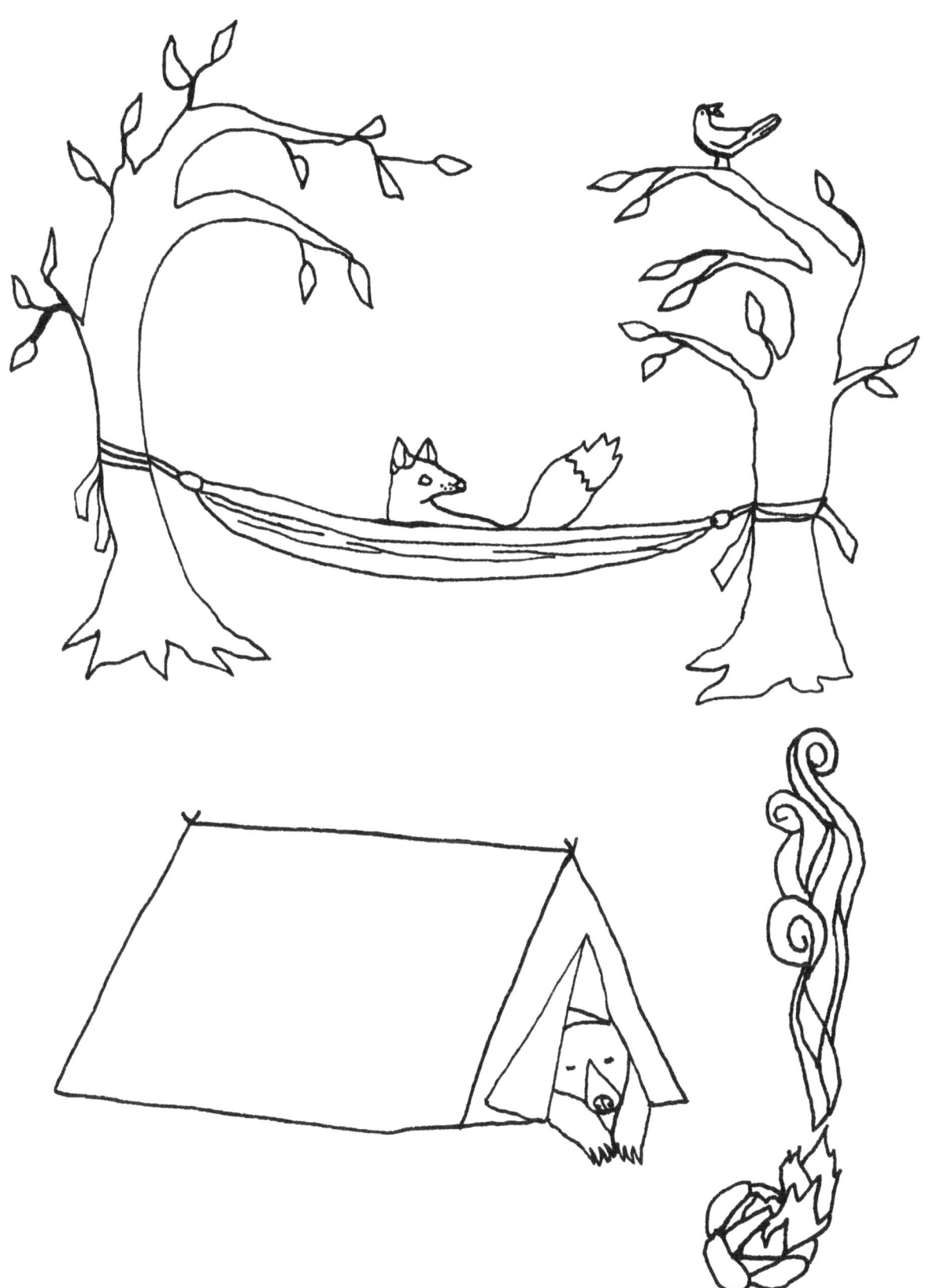

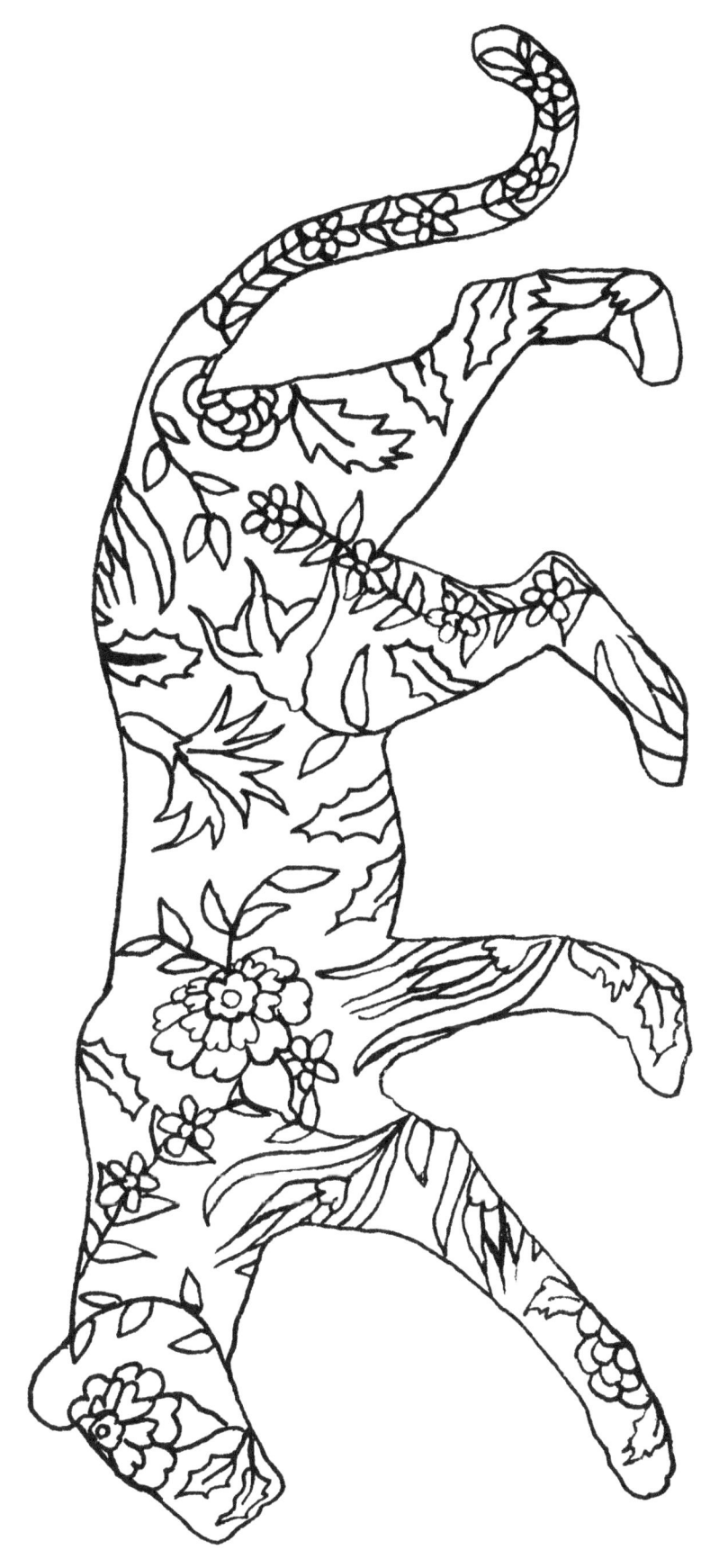

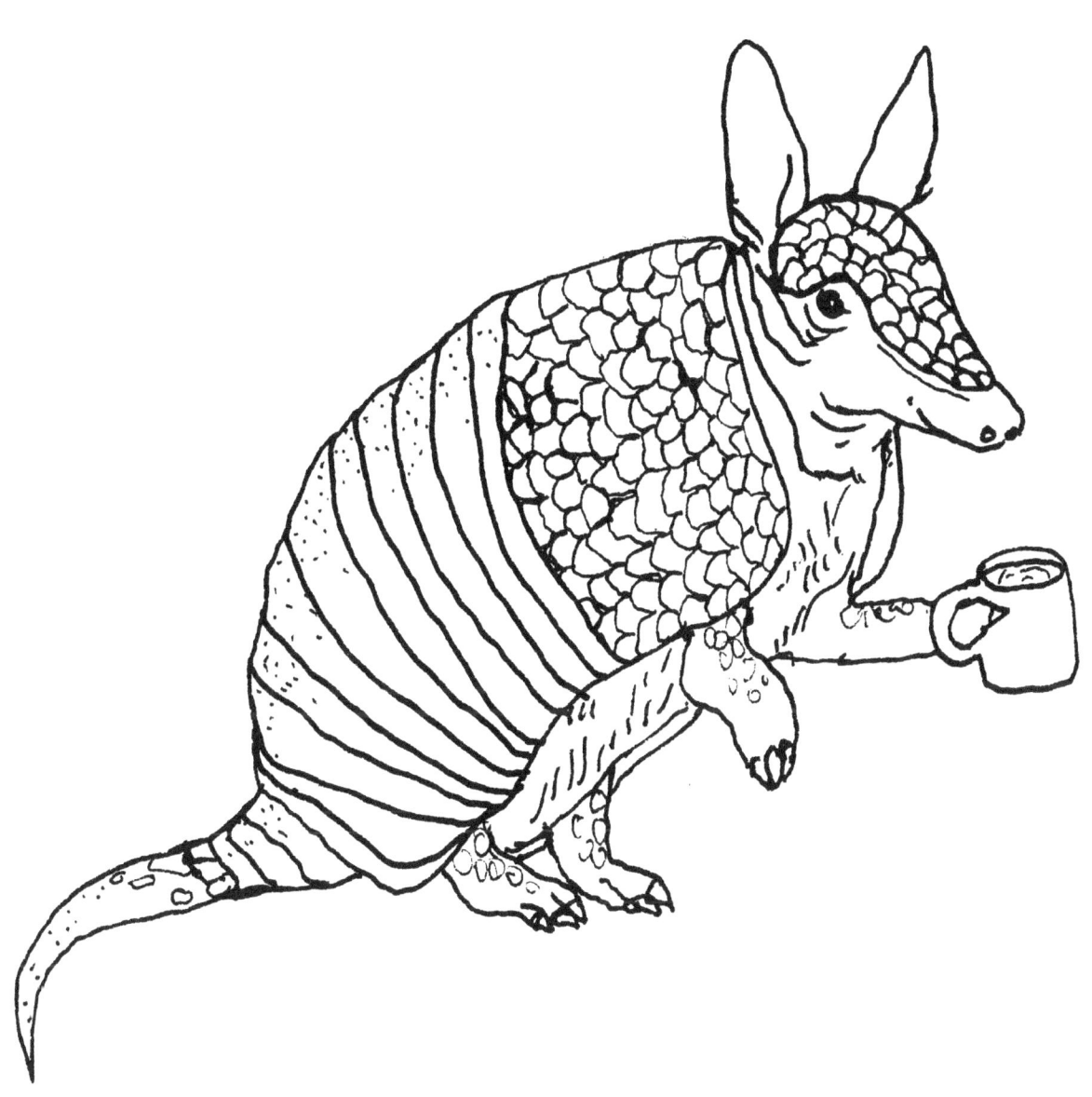

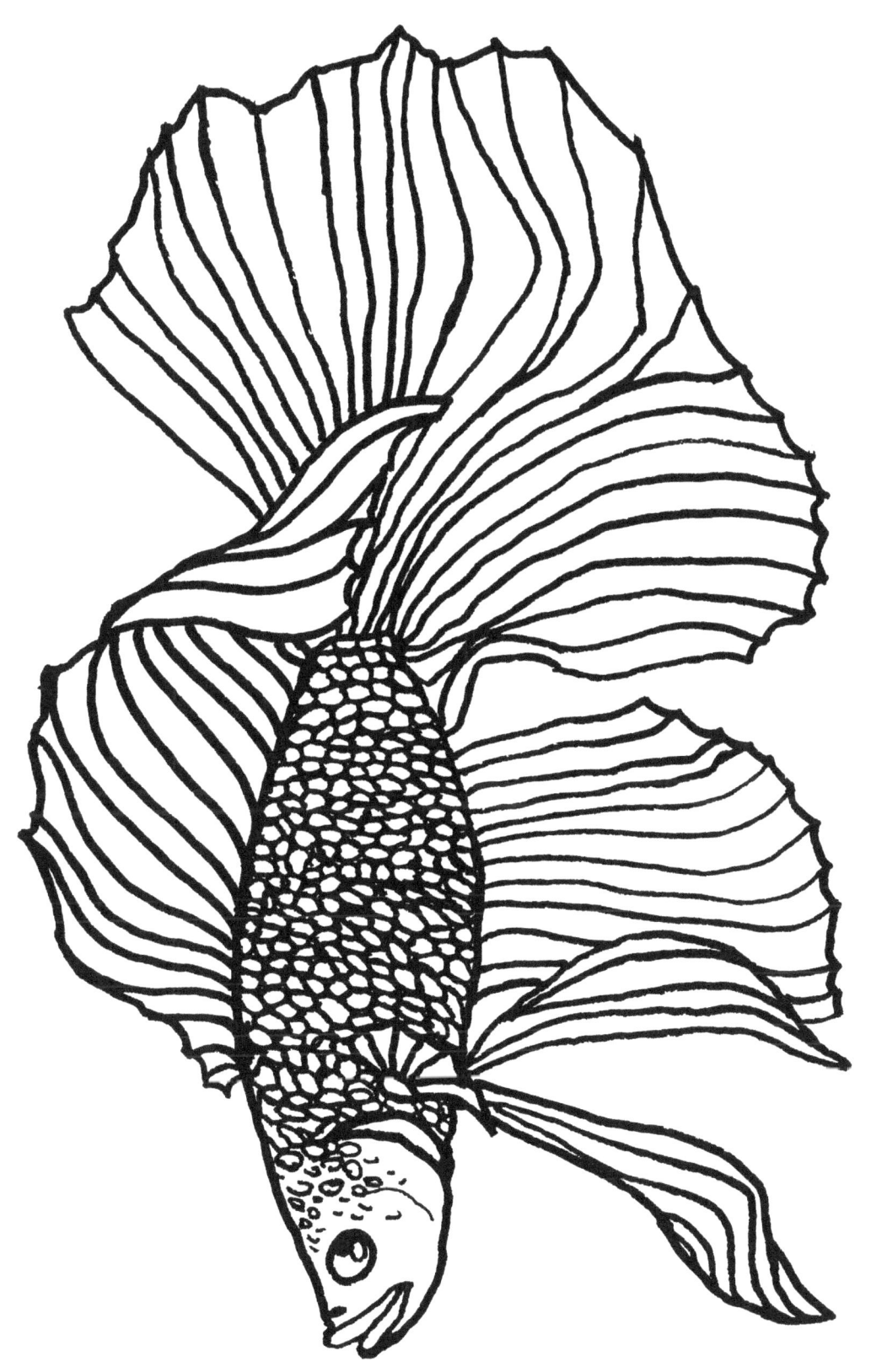

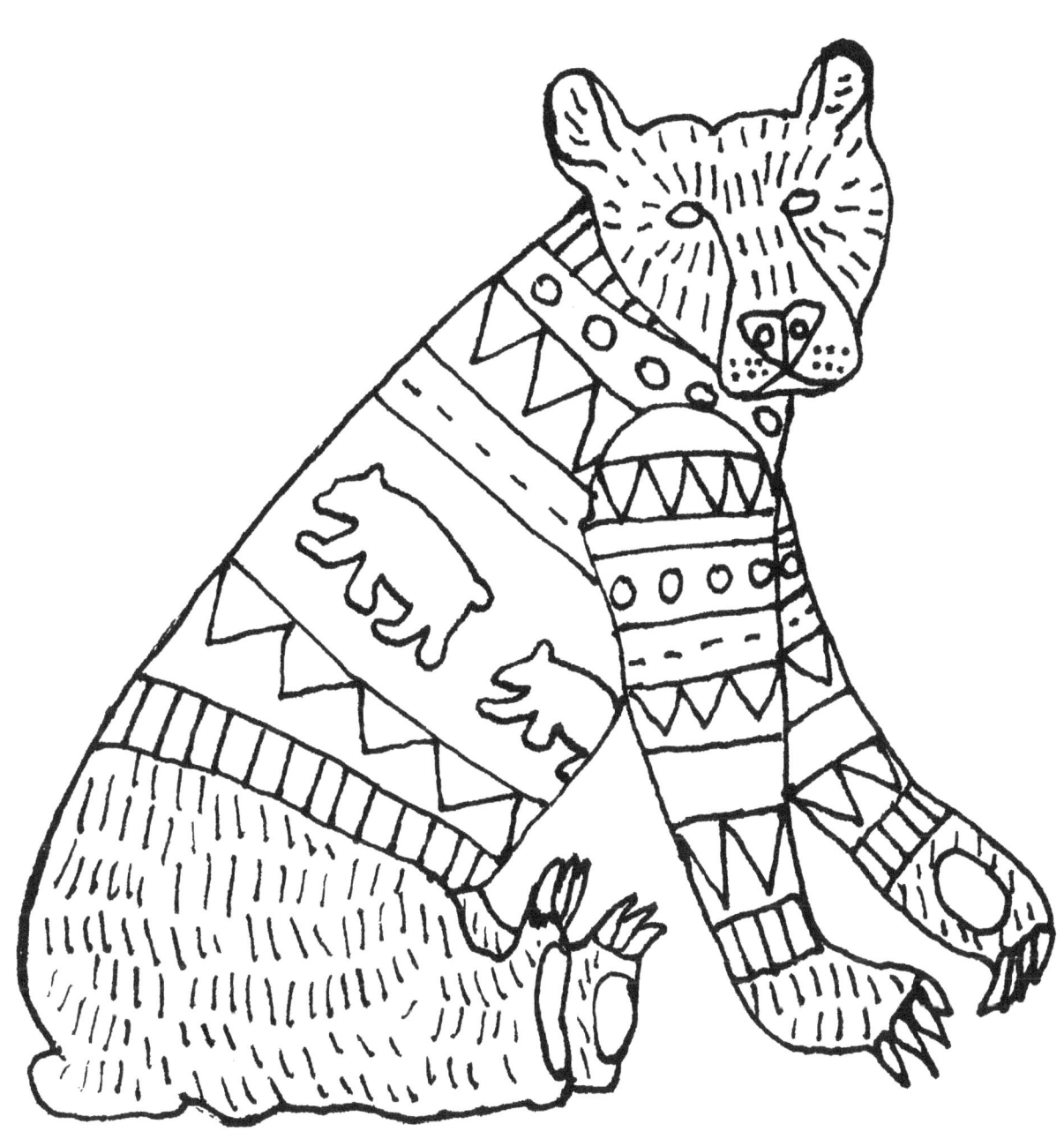

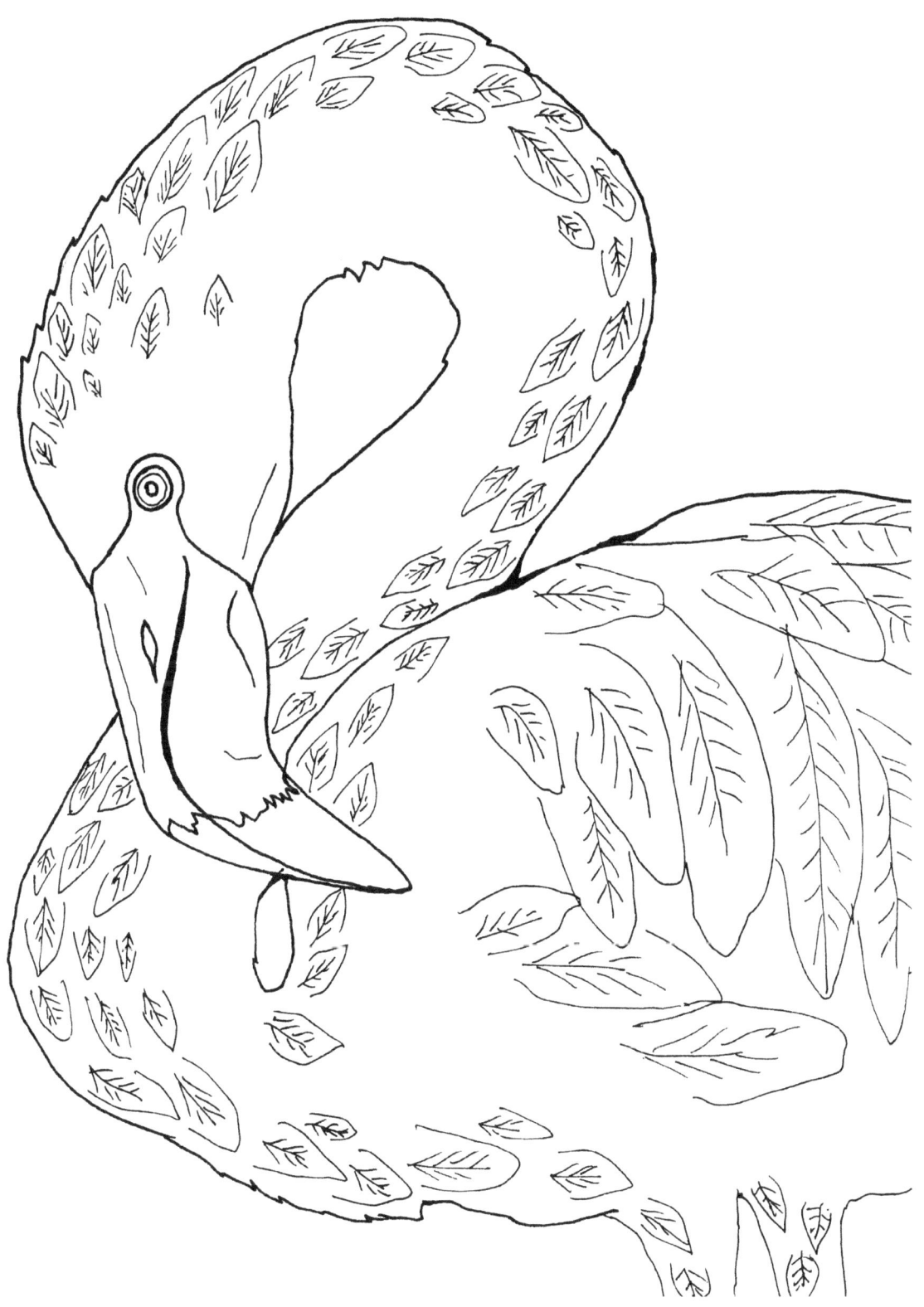

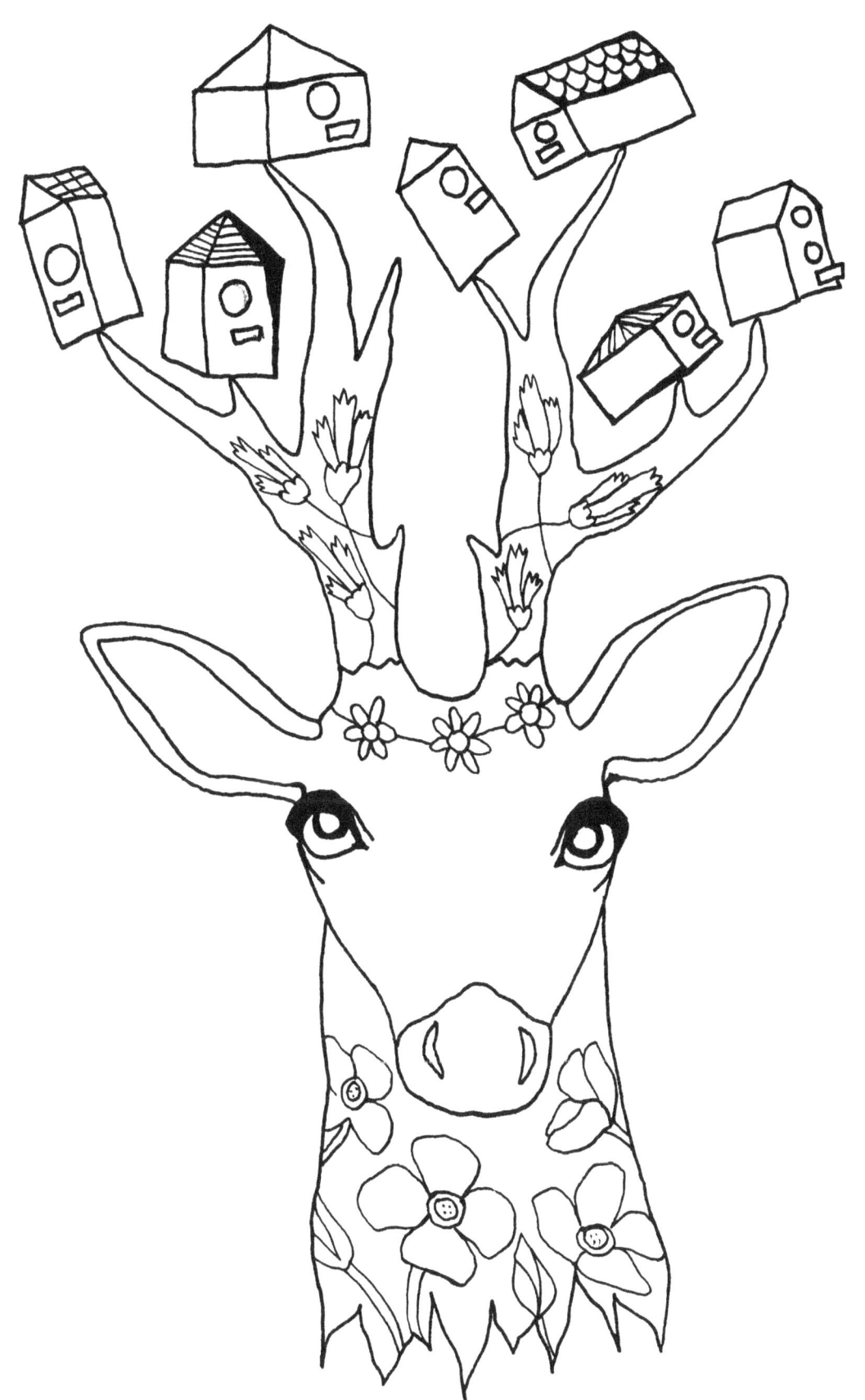

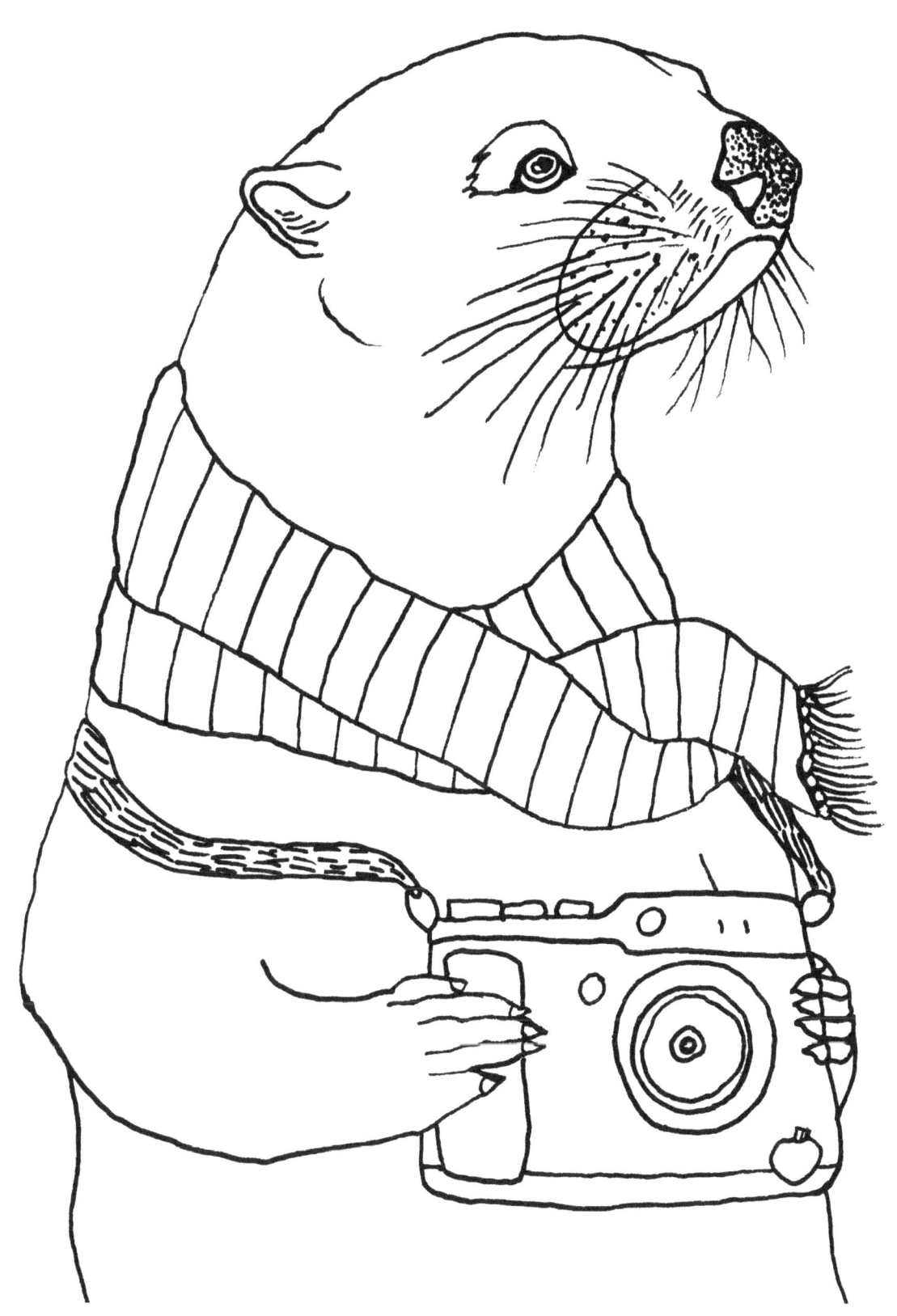

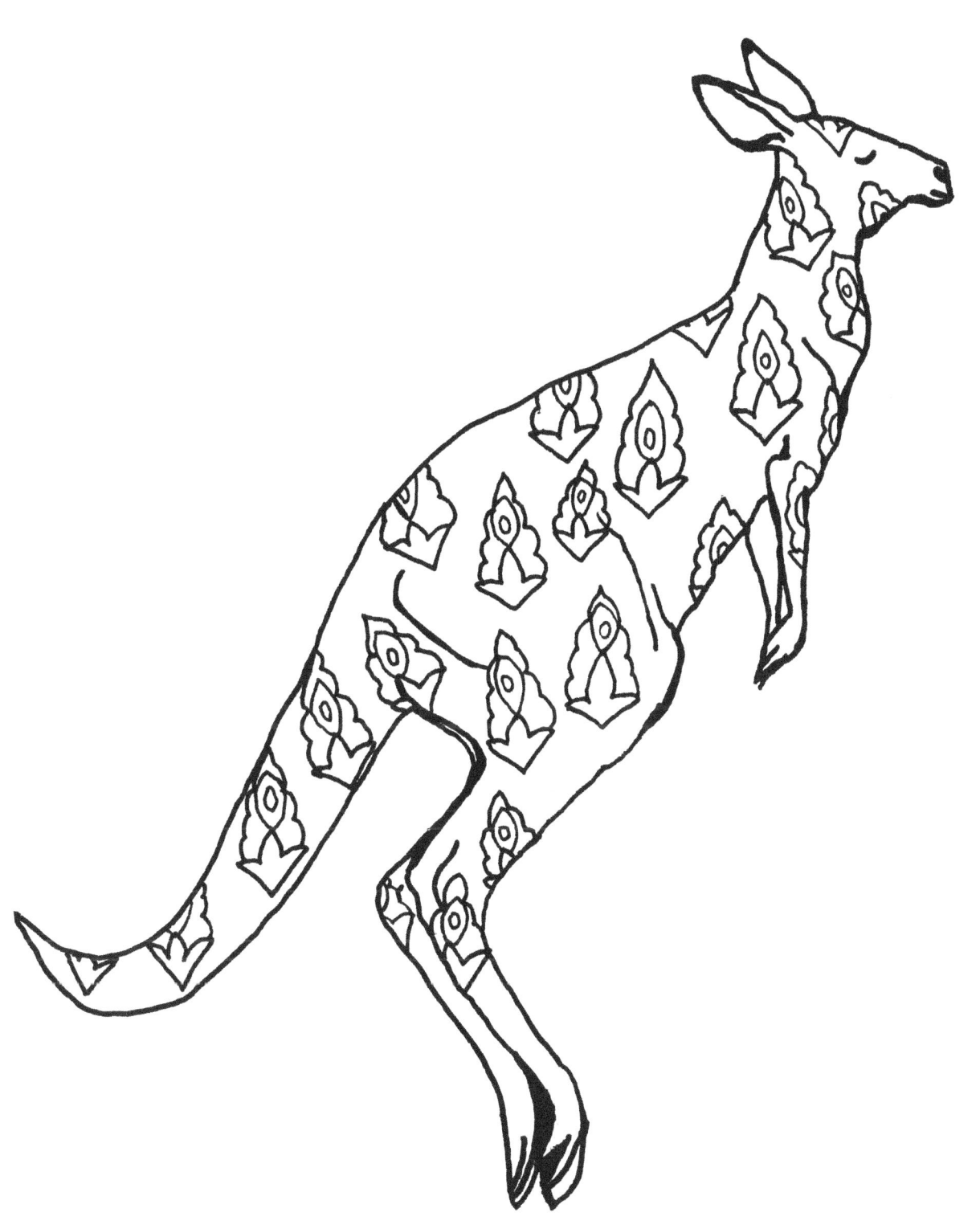

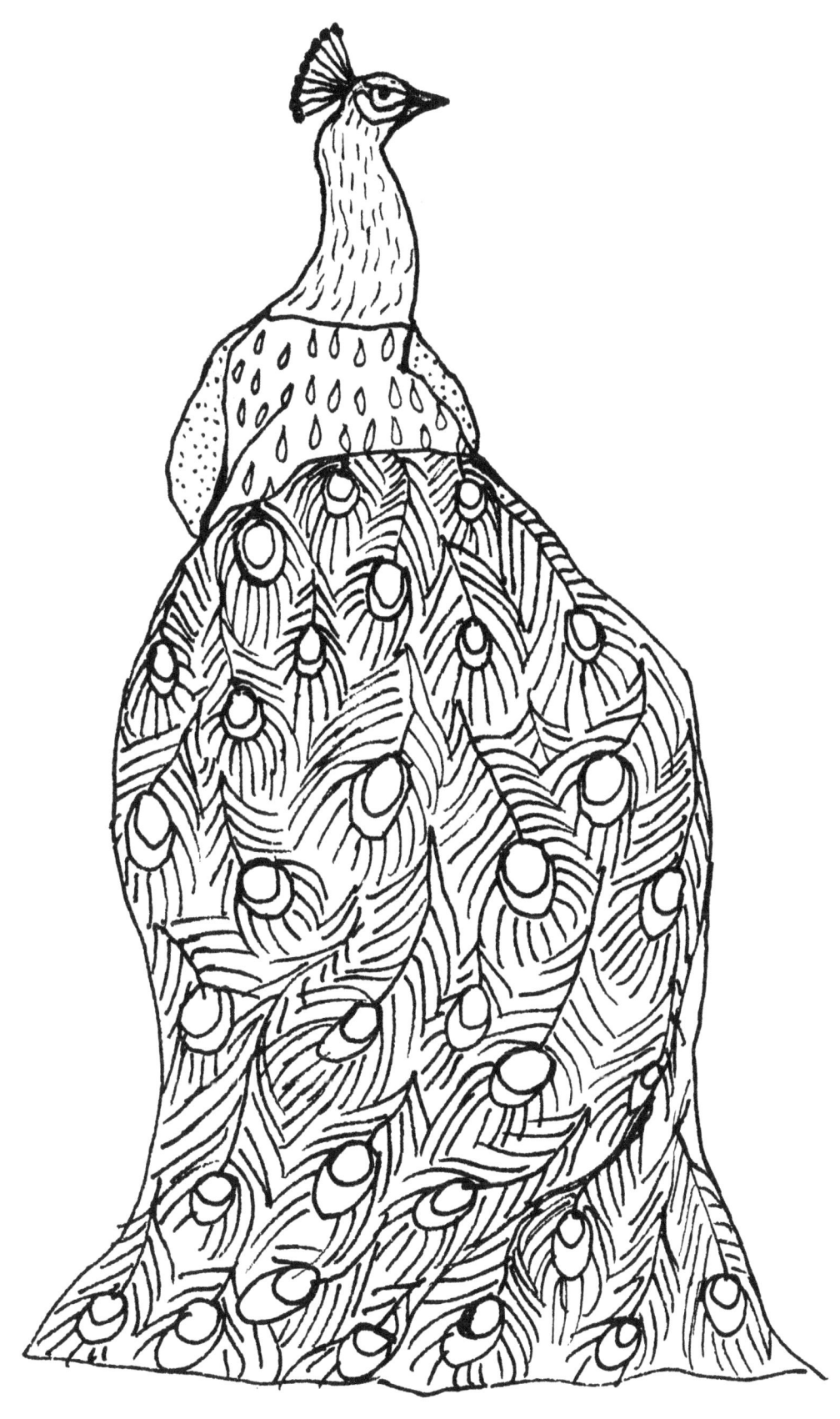

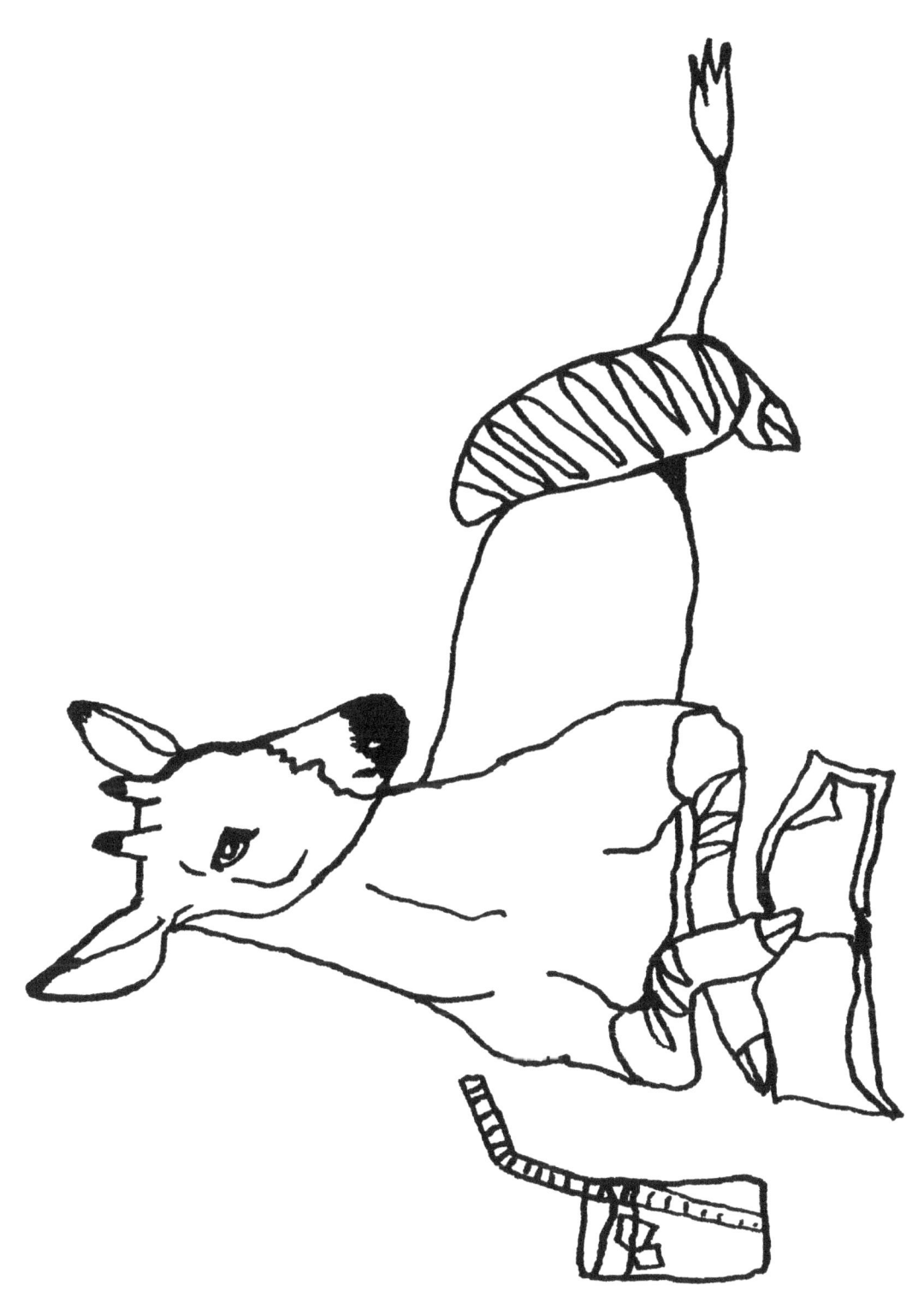

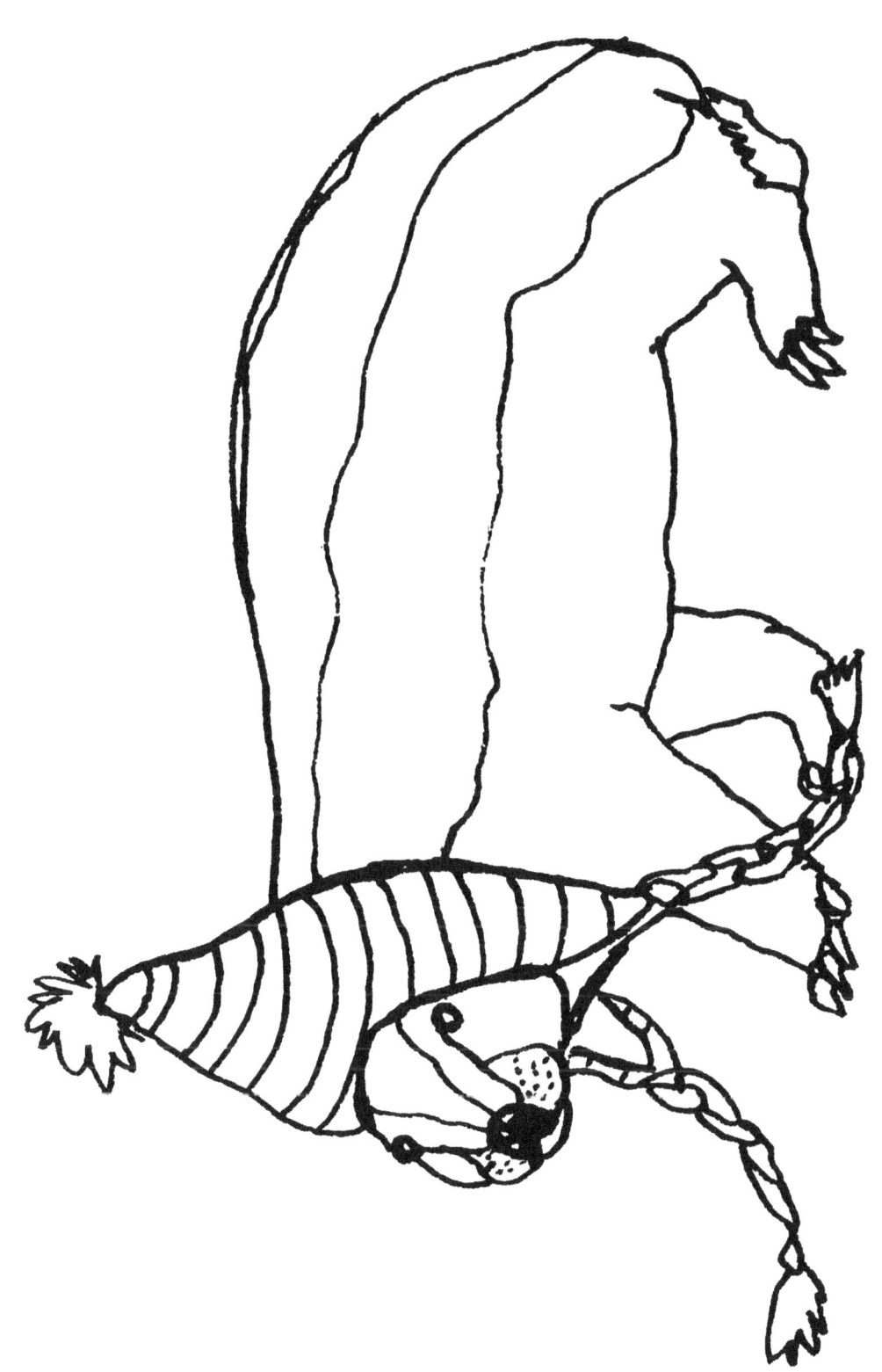

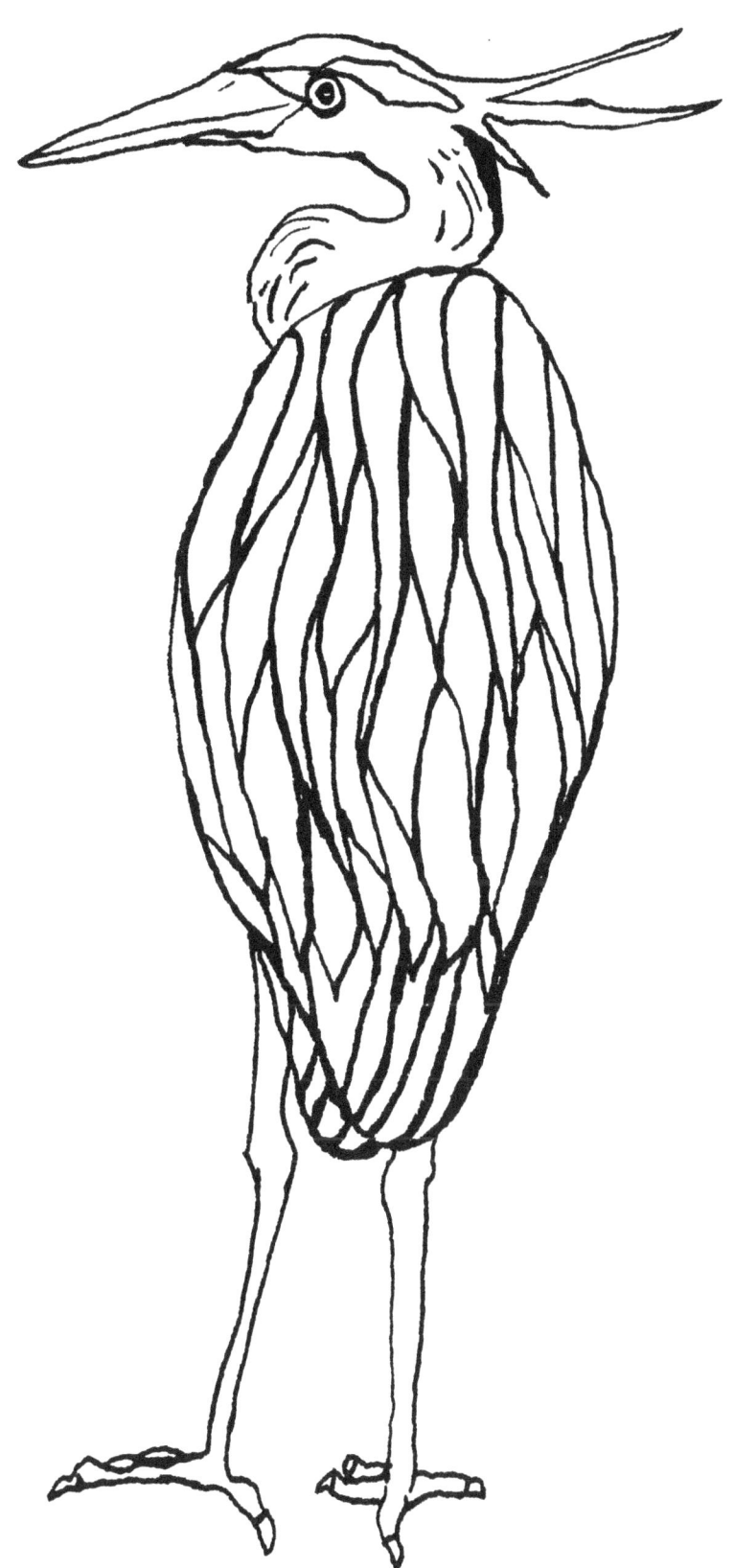

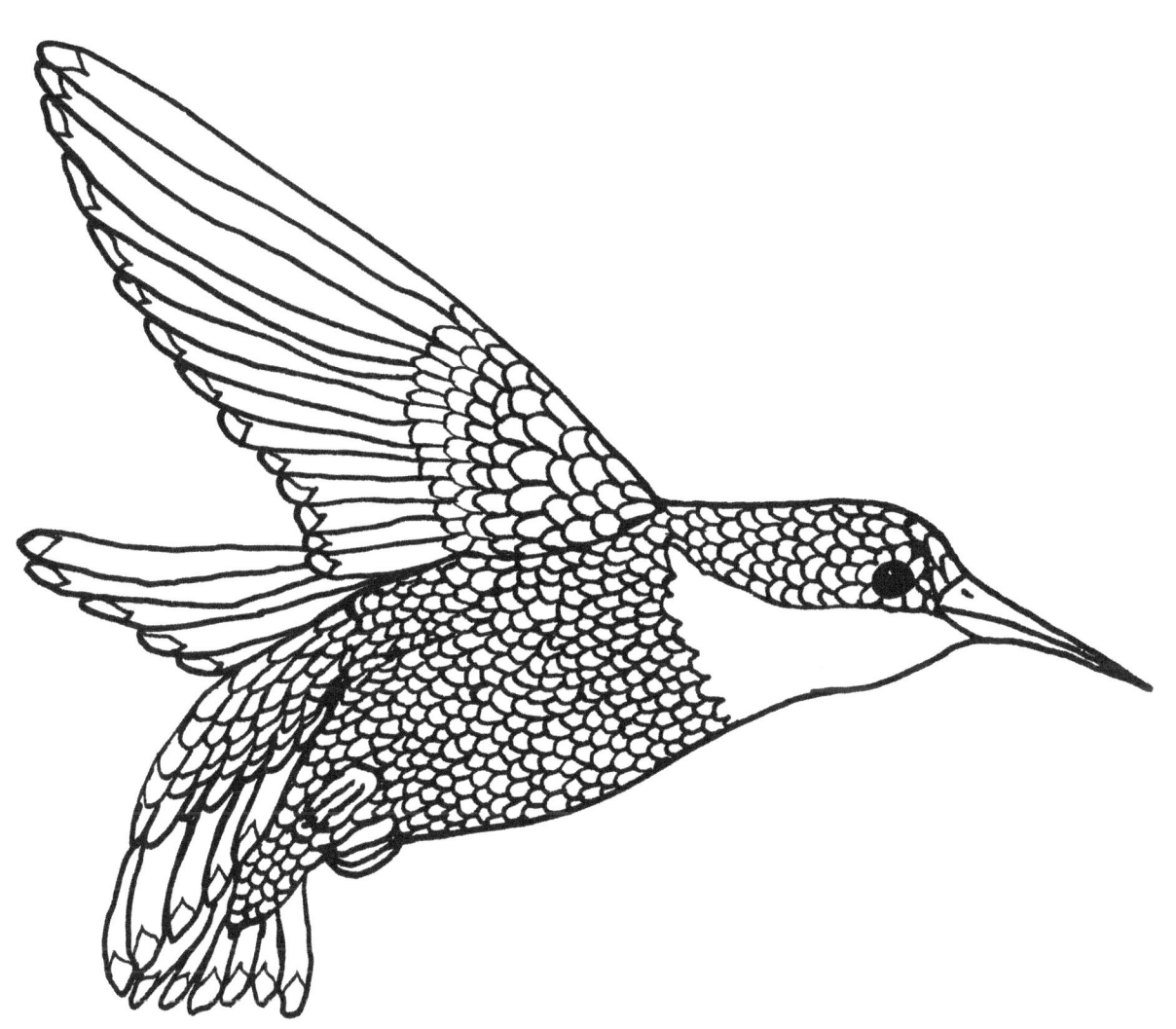

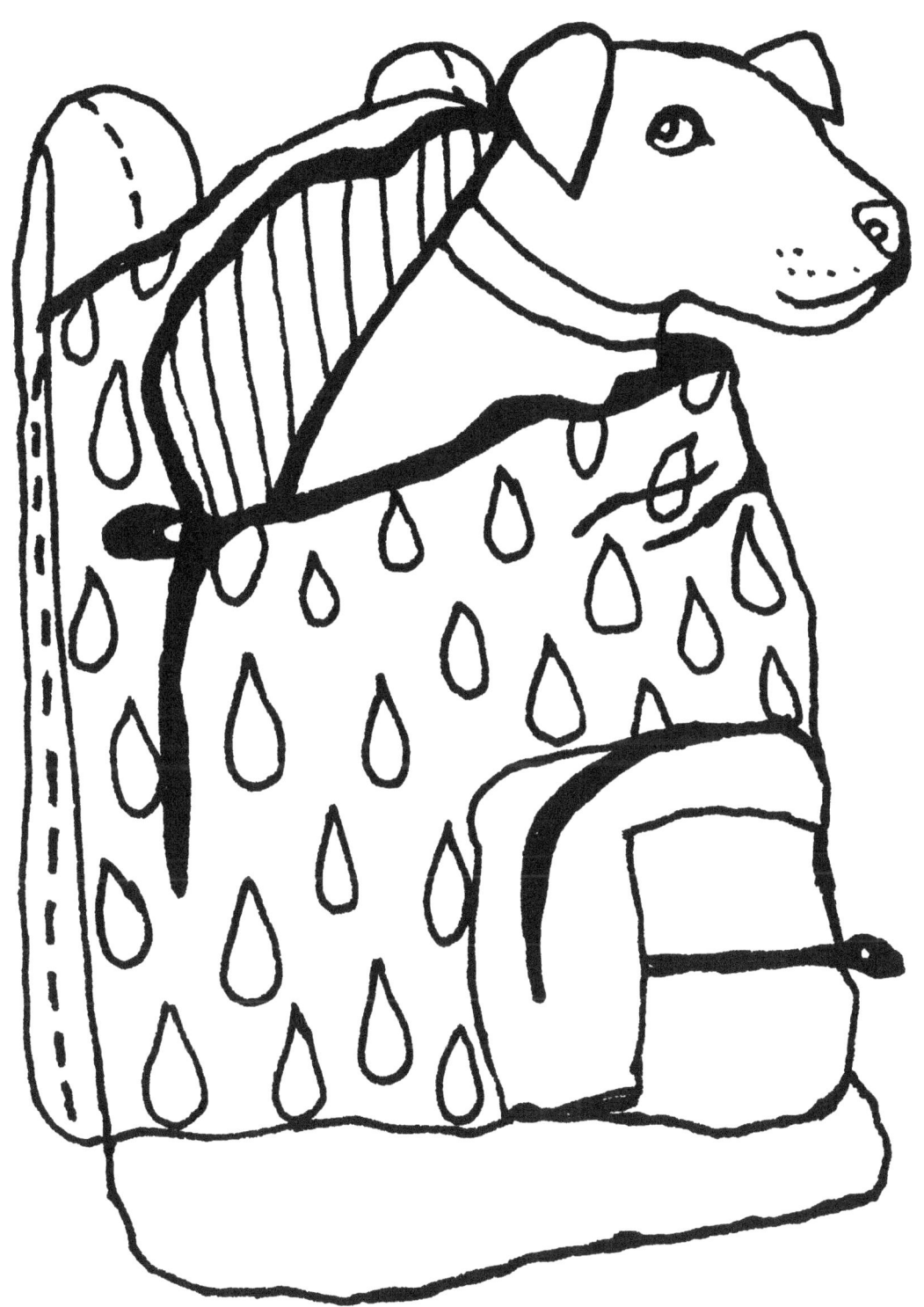

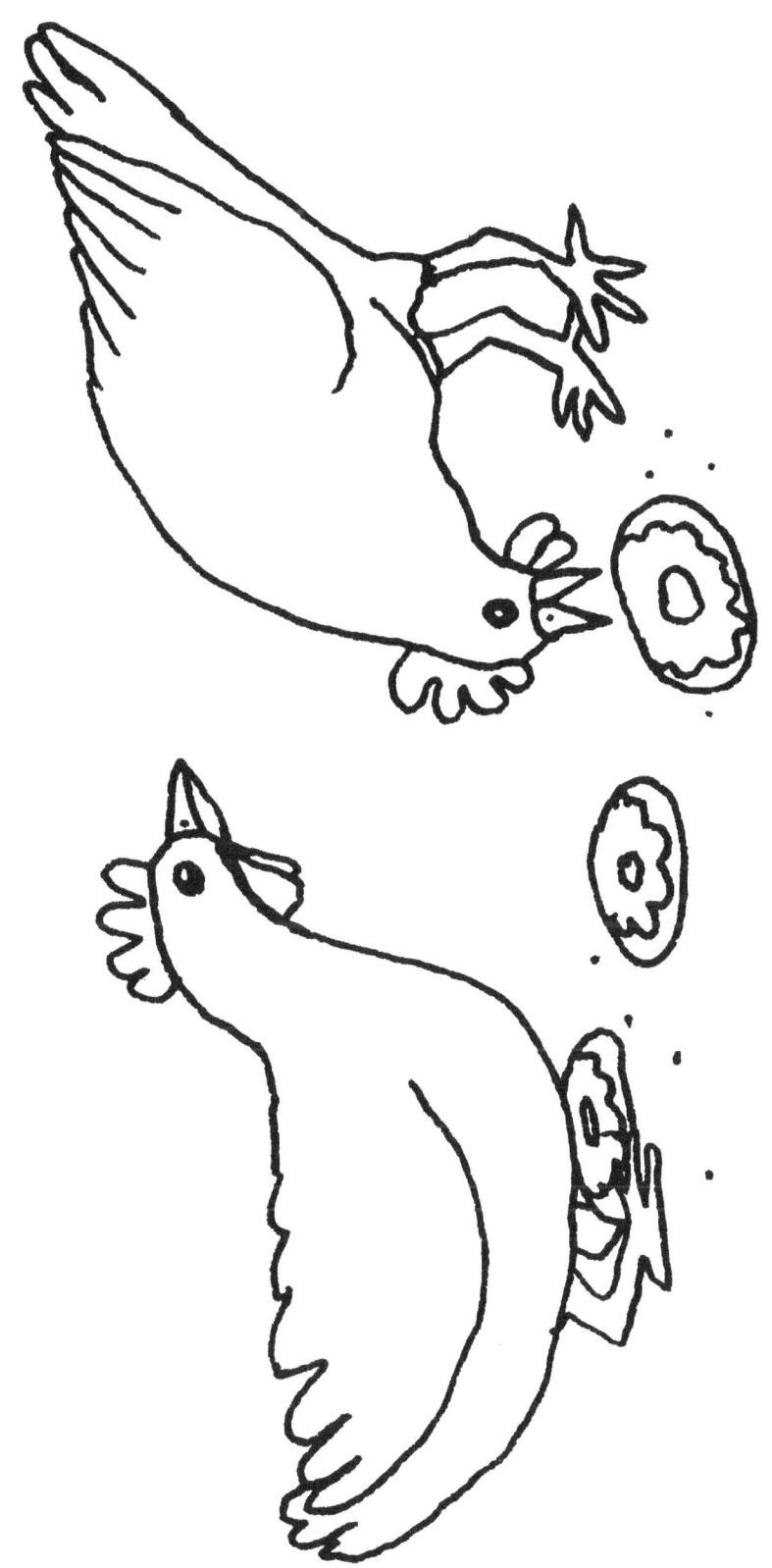

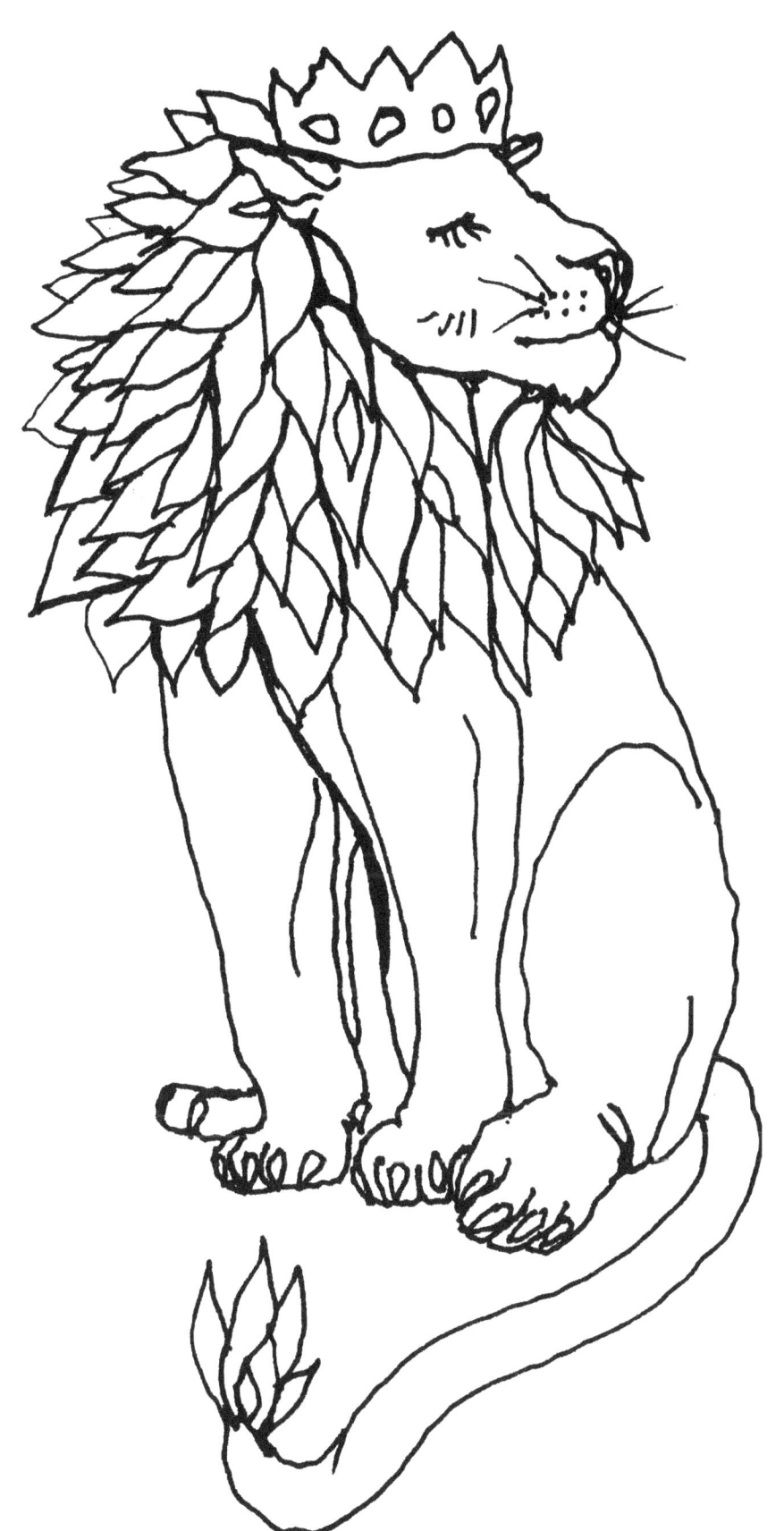

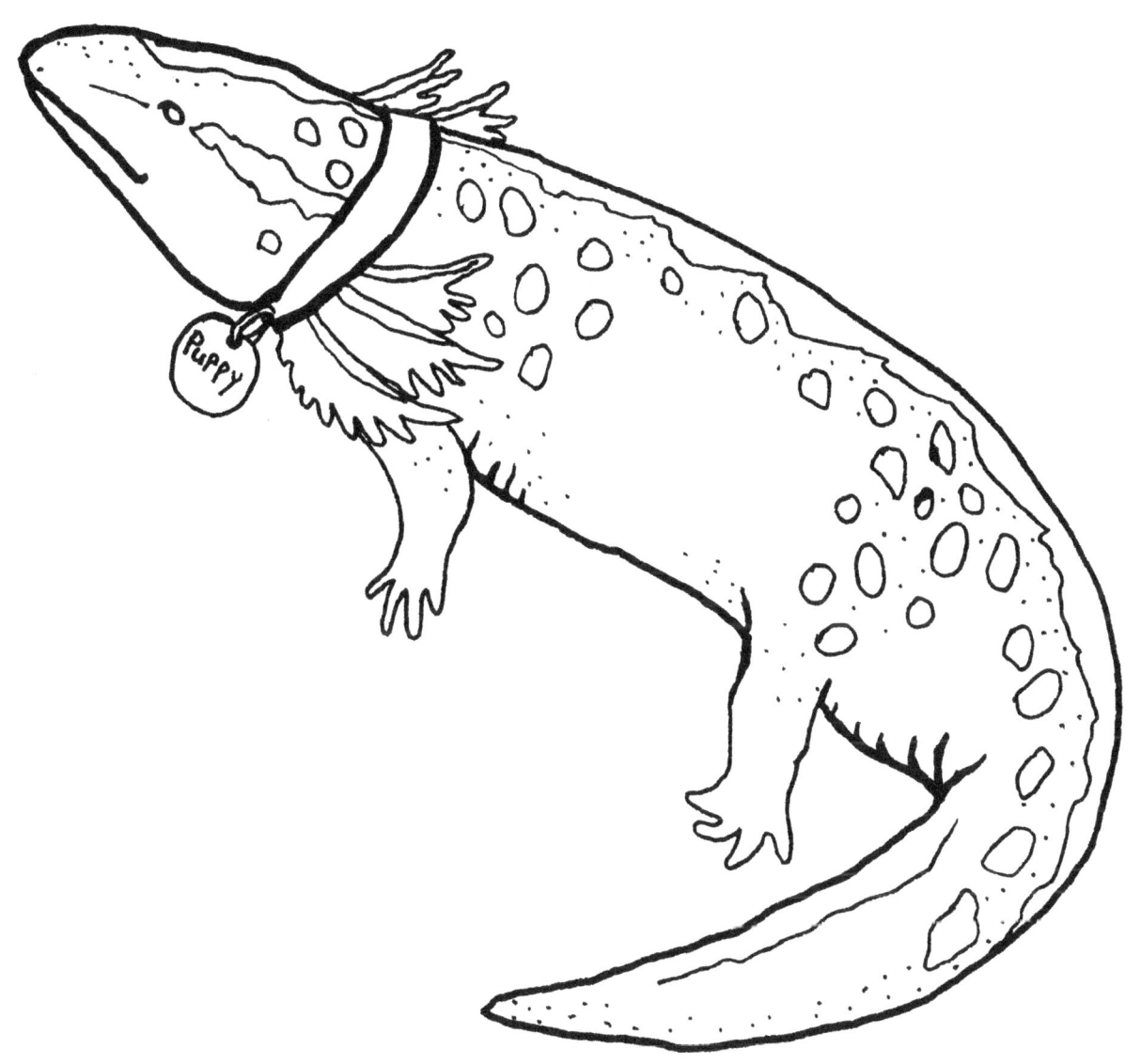

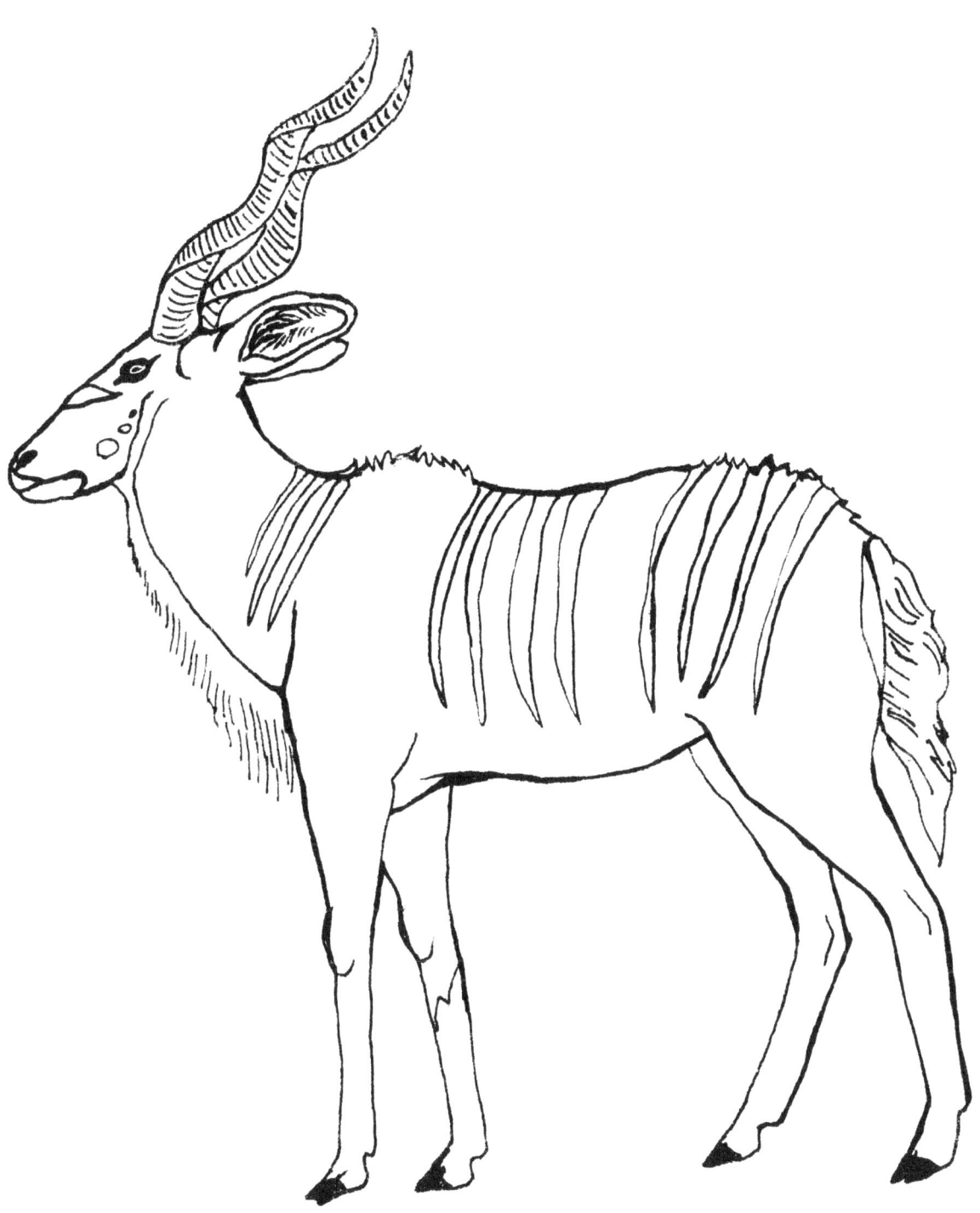

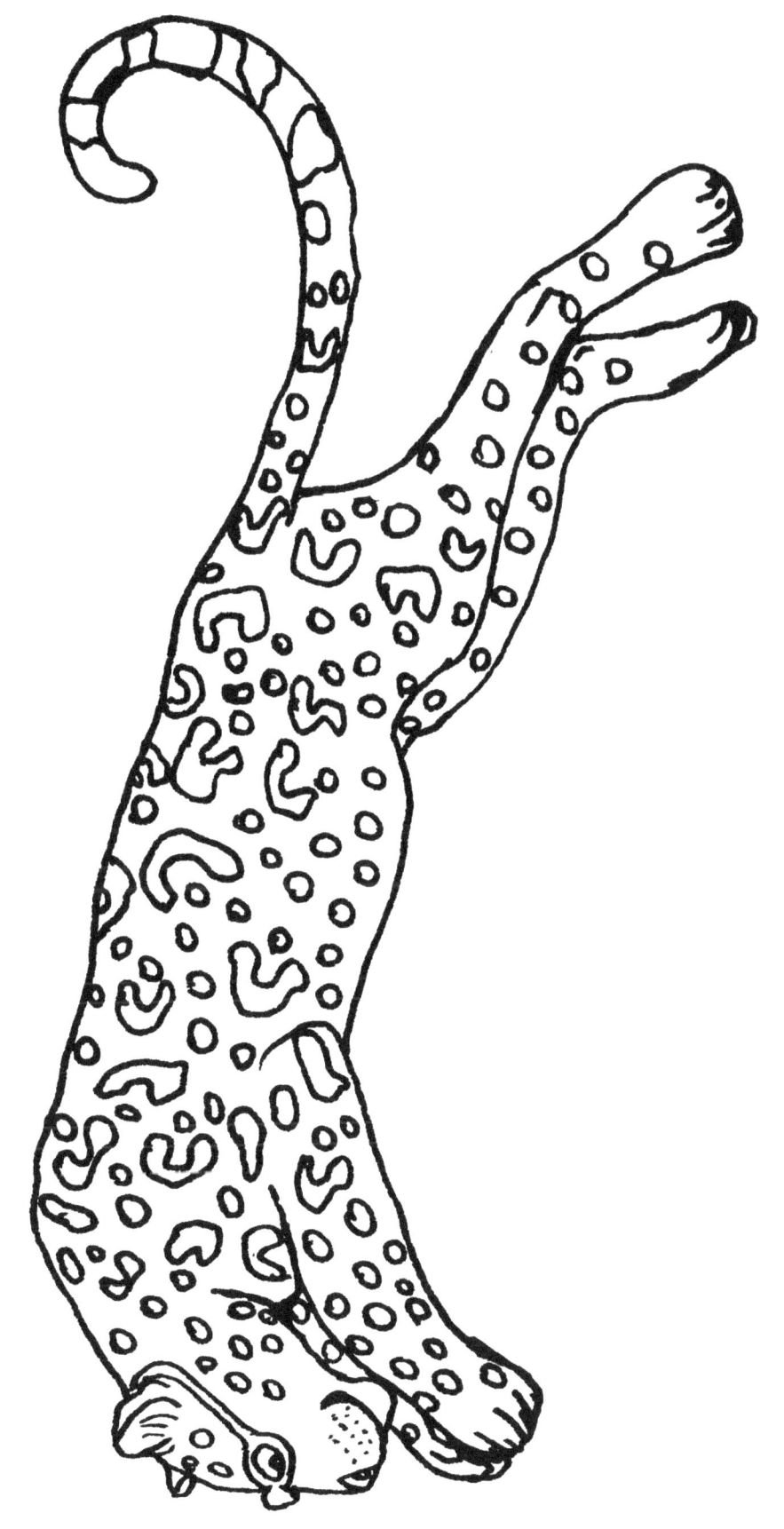

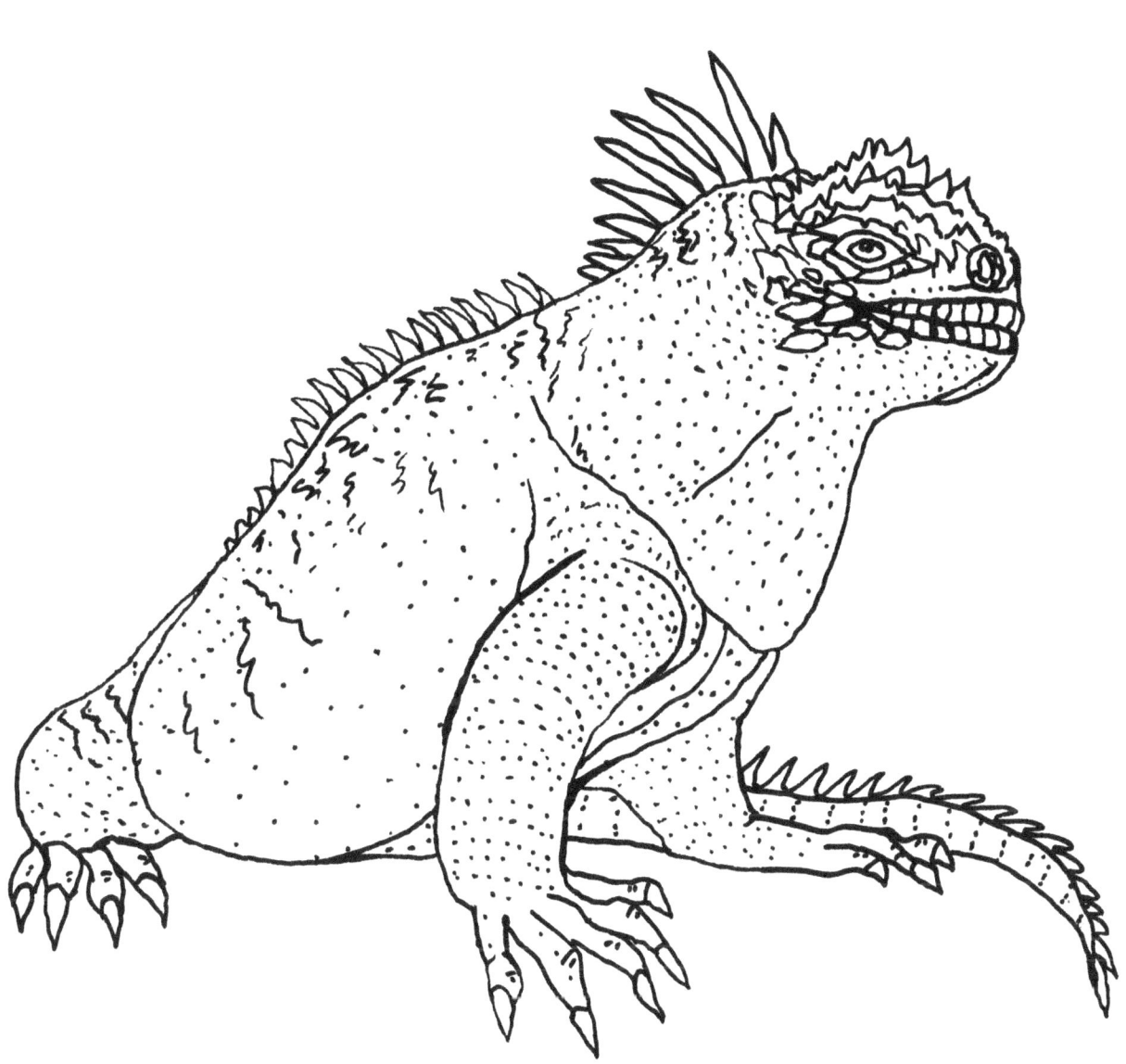

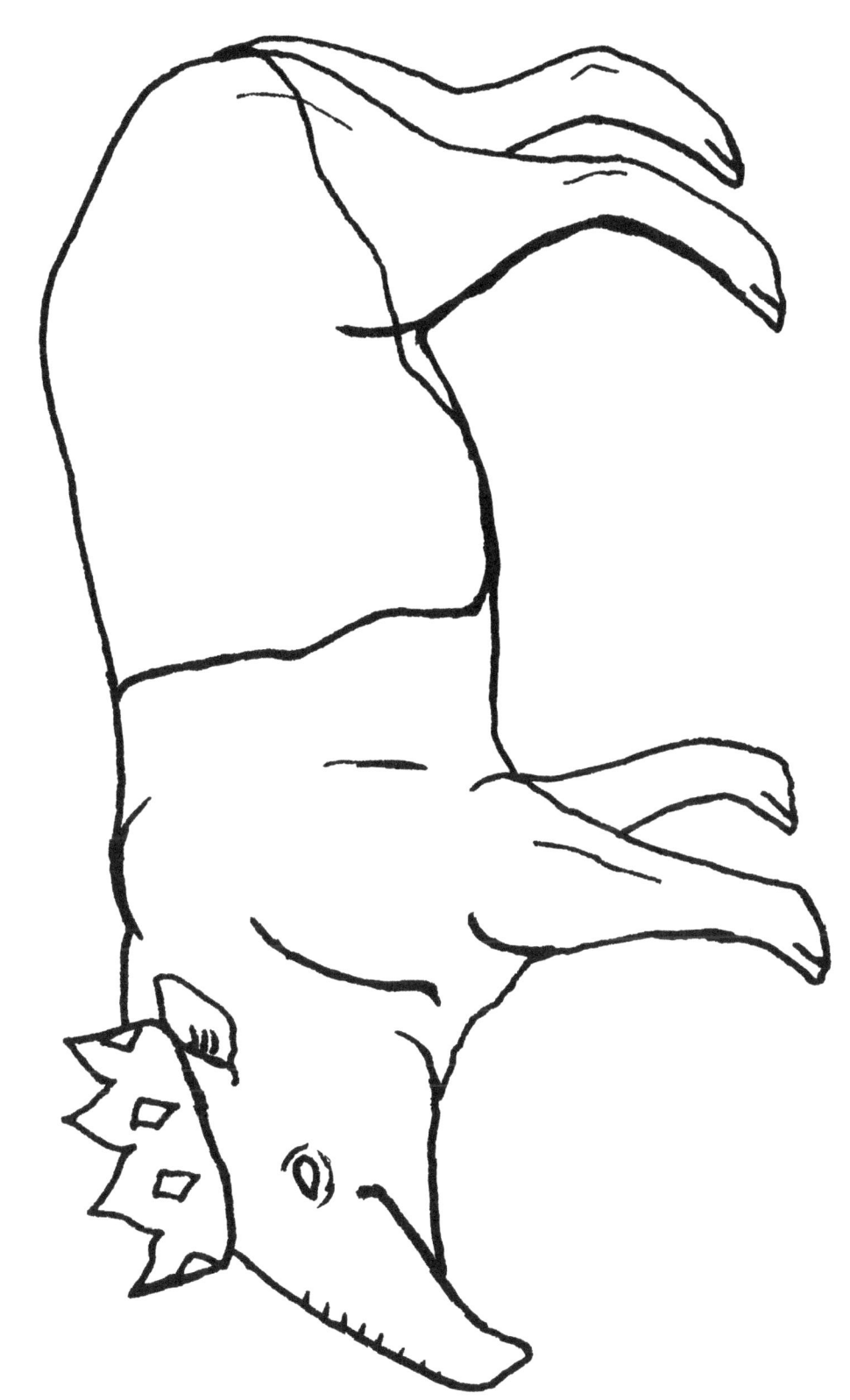

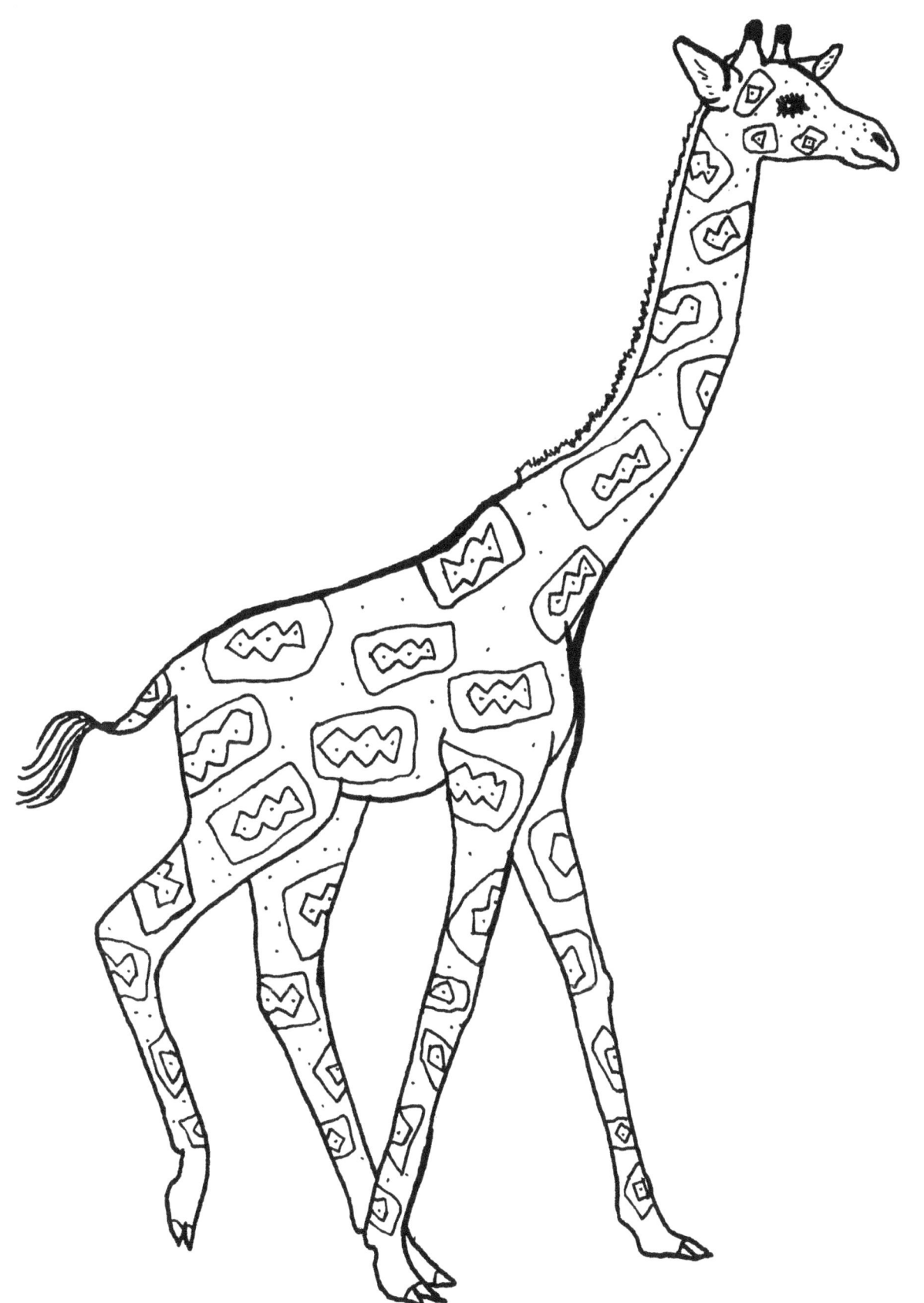

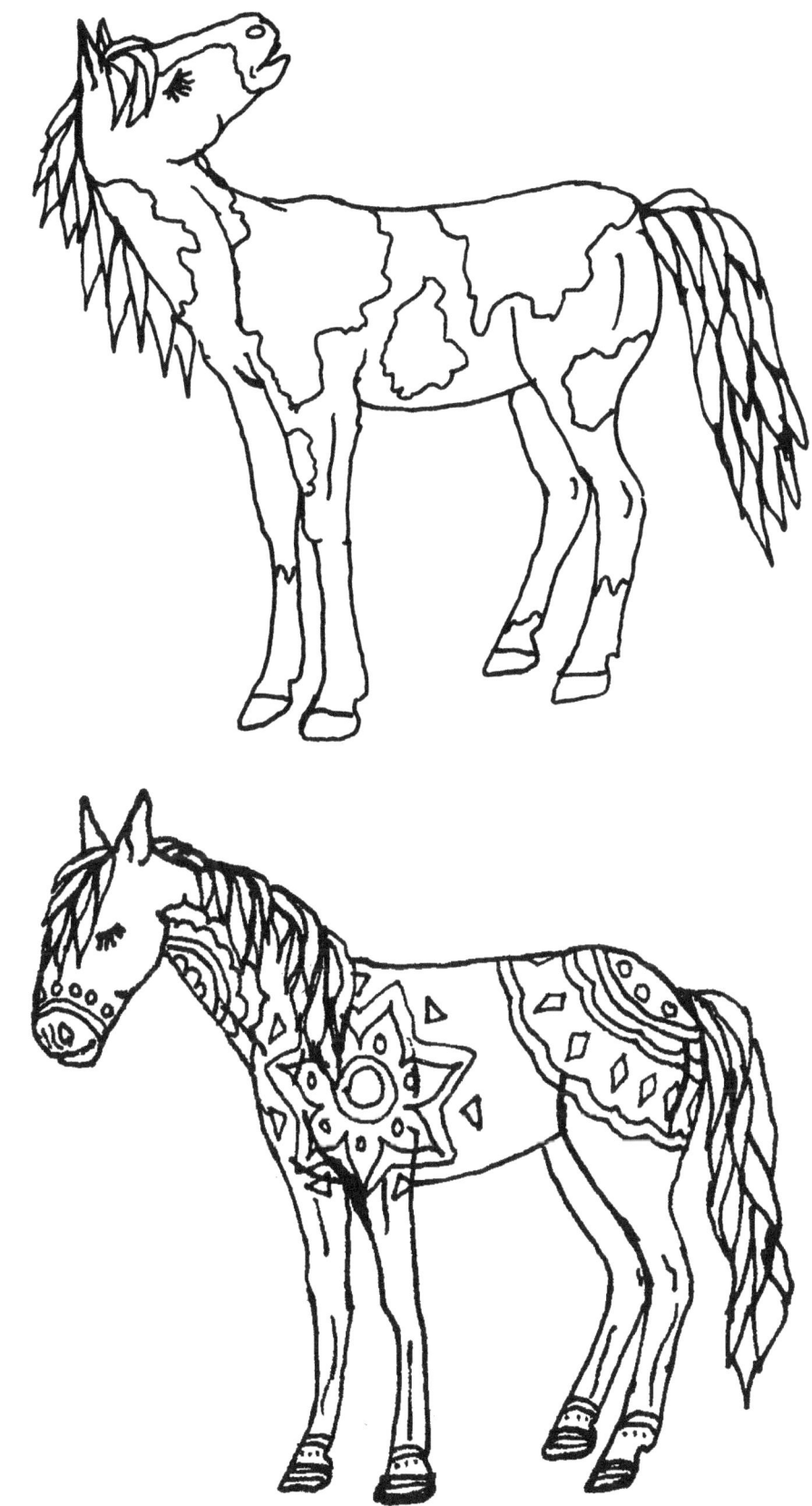

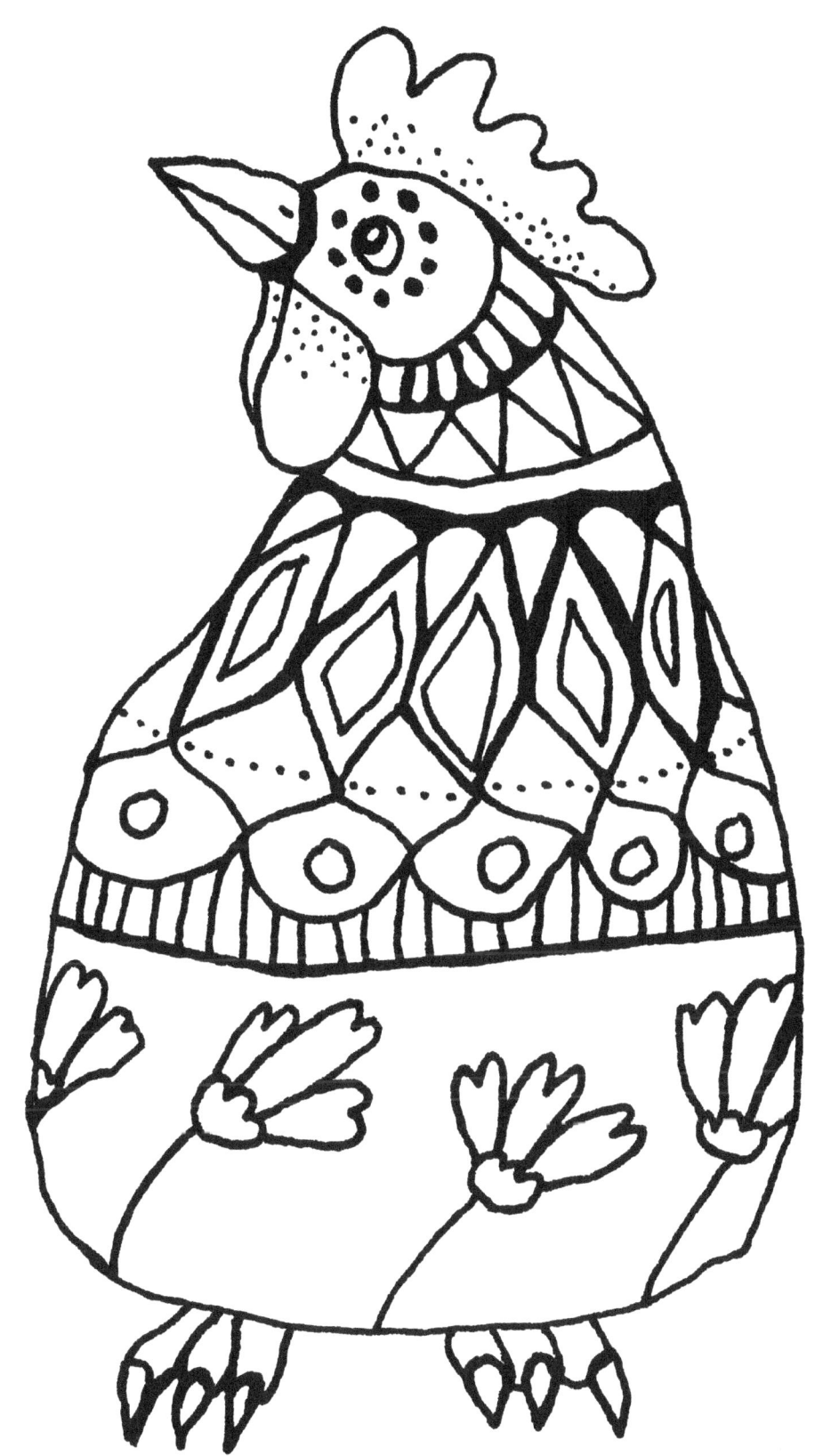

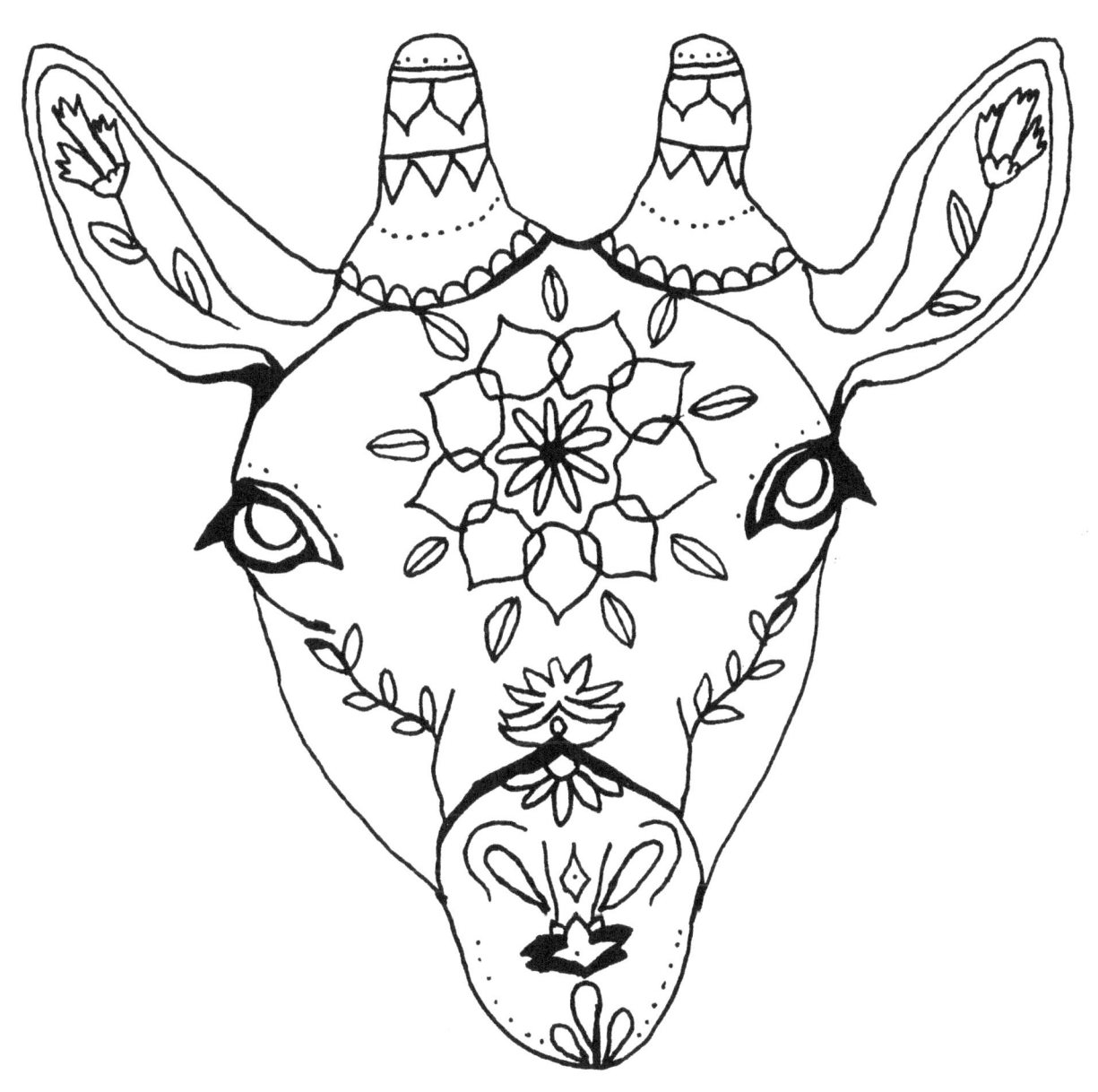

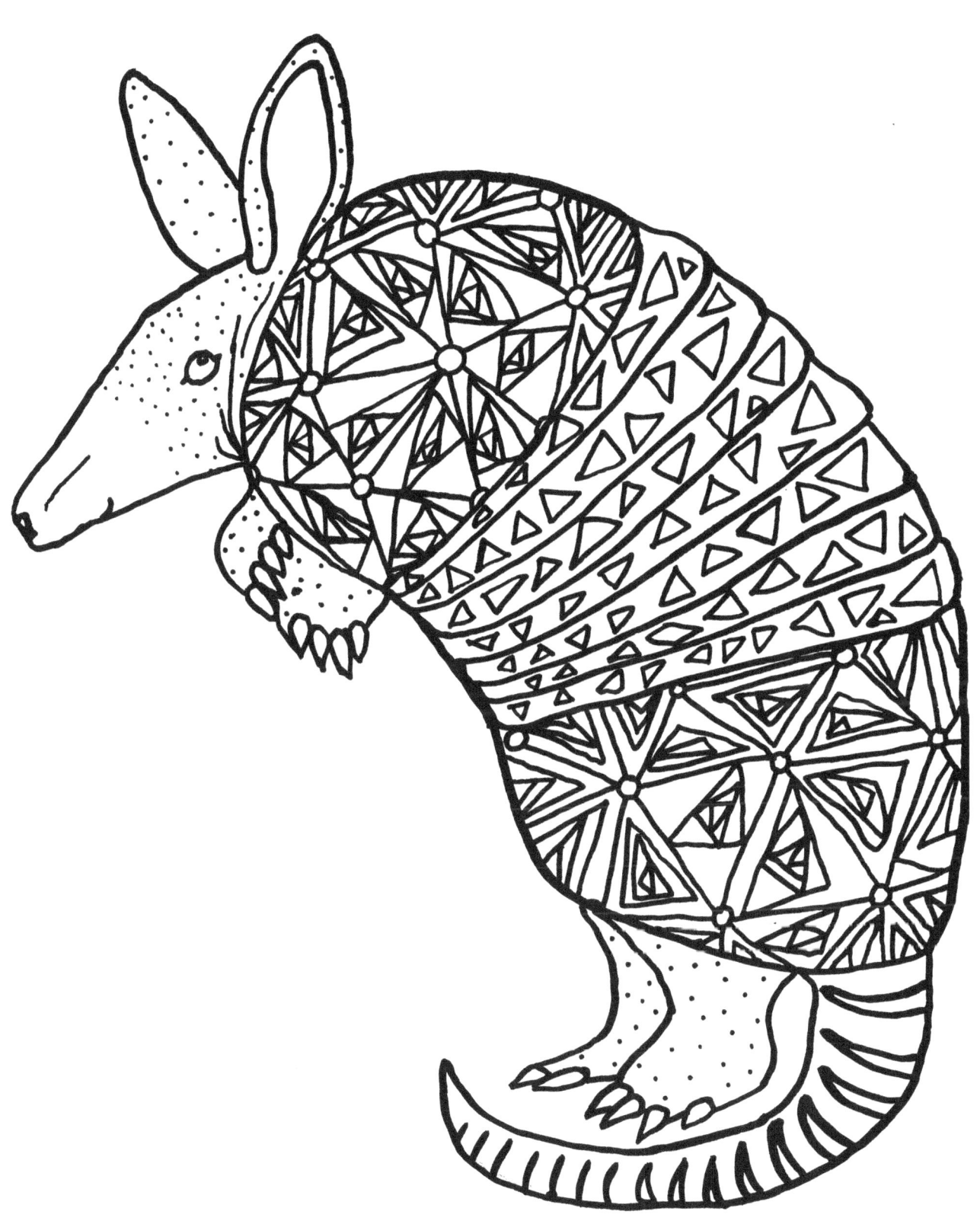

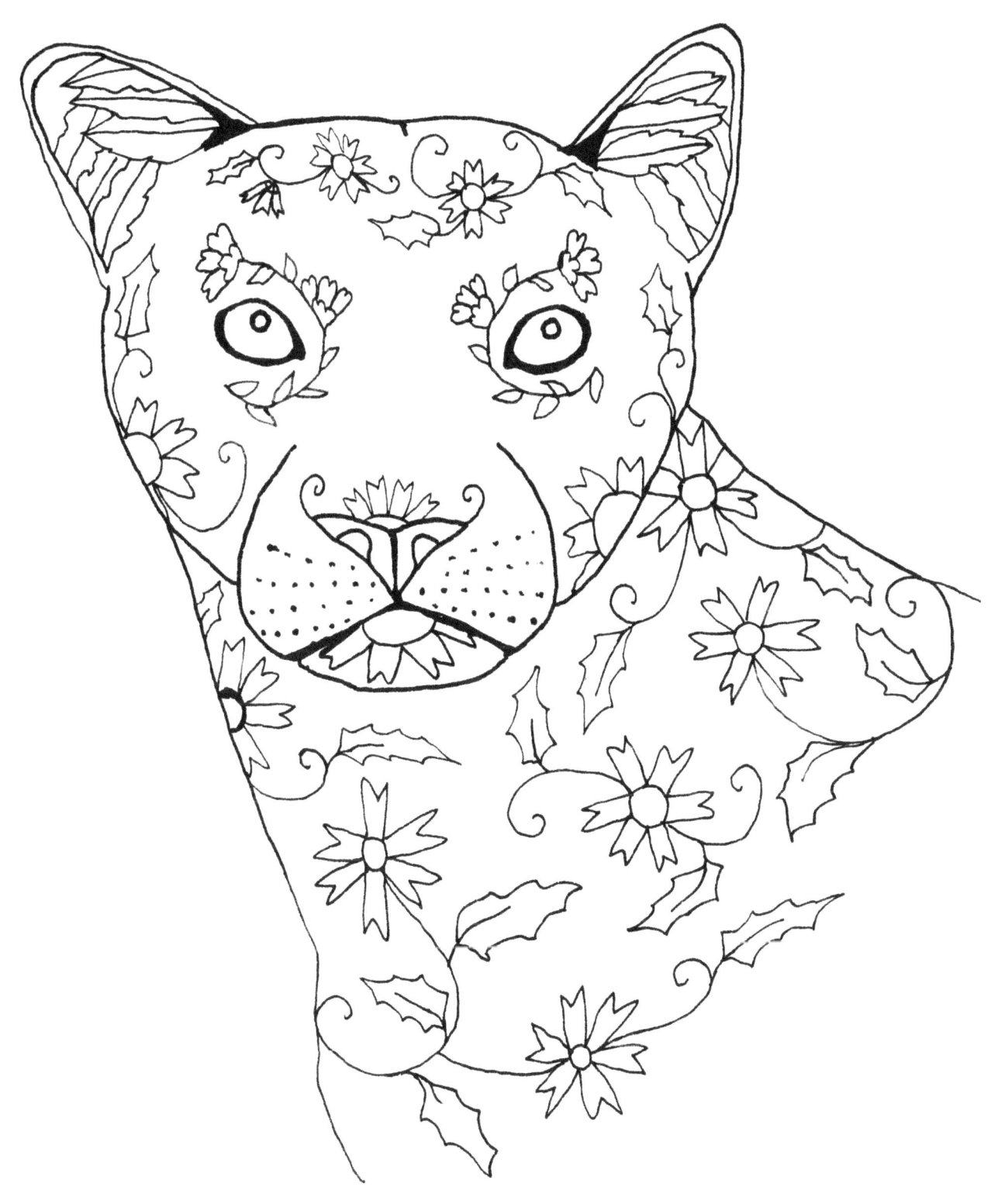

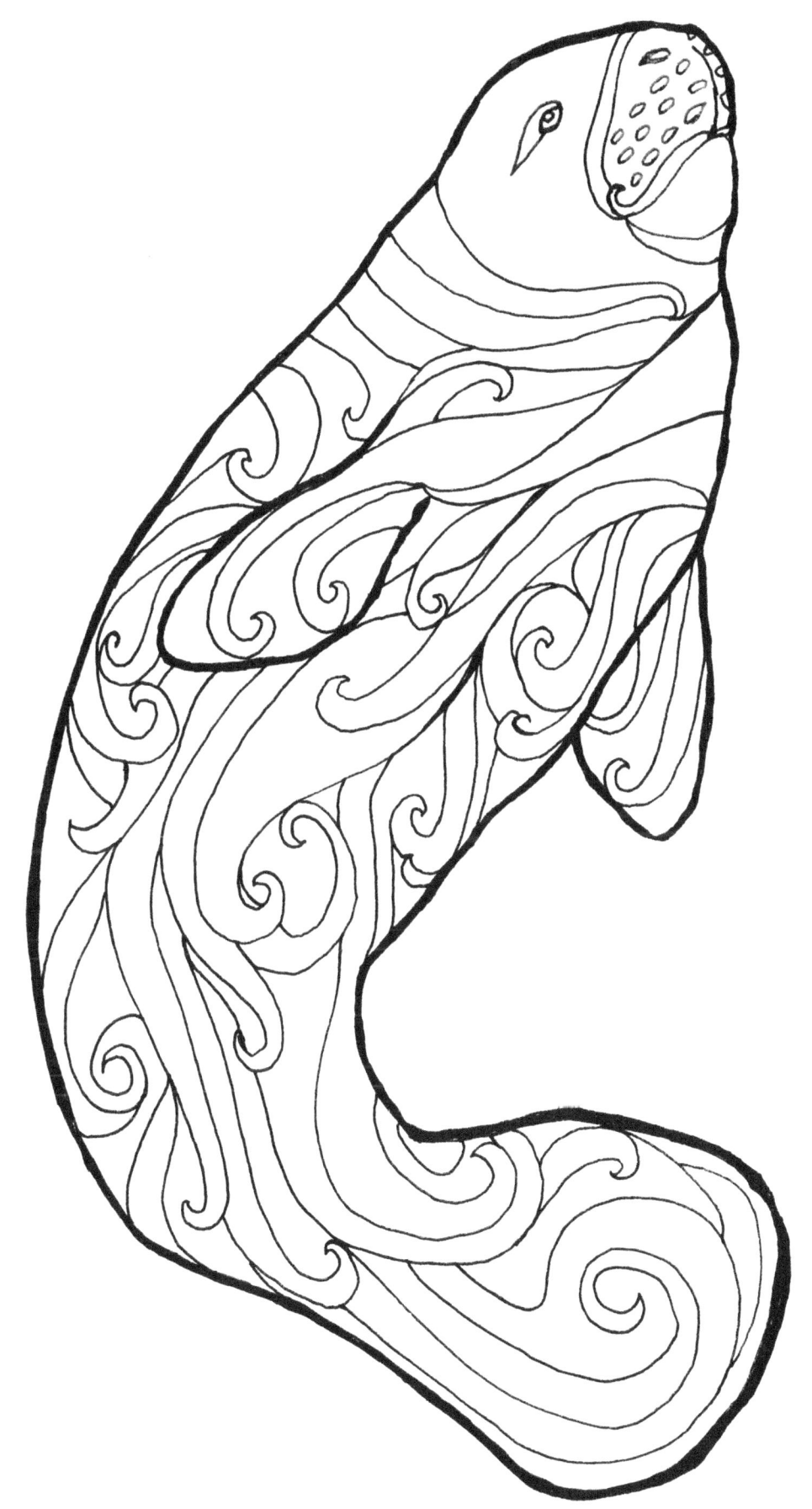

www.ingramcontent.com/pod-product-compliance
Lightning Source LLC
Chambersburg PA
CBHW080718190526
45169CB00006B/2420